Drawing **Portraits**

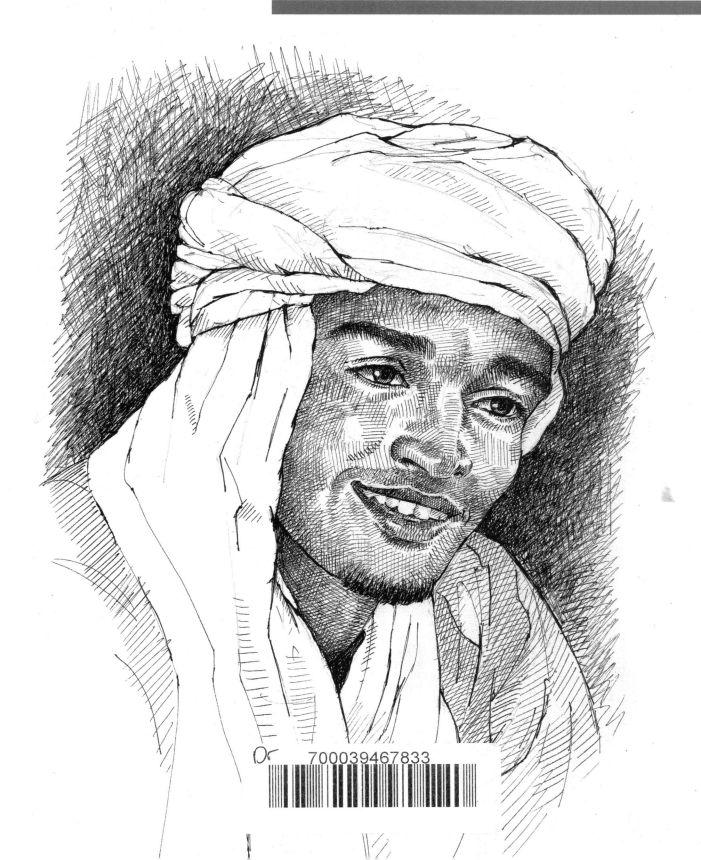

Dedication

For Eric, who has been a willing and long-suffering model for me in many portrait classes; for his continuing support and encouragement throughout my artistic career.

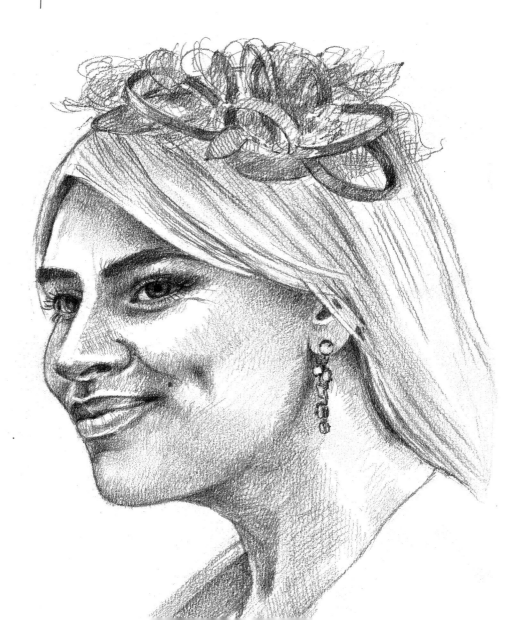

Drawing **Portraits**

Carole Massey

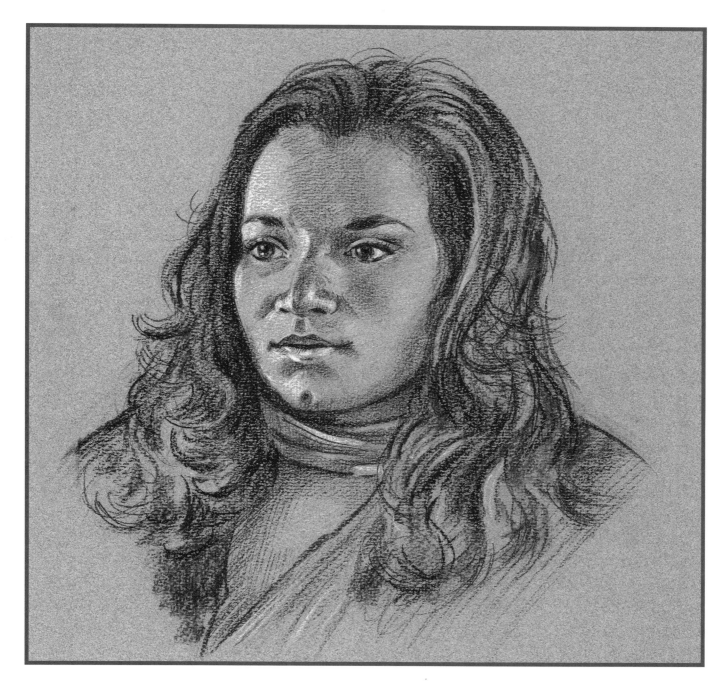

SEARCH PRESS

First published in Great Britain 2012

Search Press Limited
Wellwood, North Farm Road,
Tunbridge Wells, Kent TN2 3DR

ISBN: 978-1-84448-747-9

Suppliers
If you have difficulty in obtaining
any of the materials and equipment
mentioned in this book, then please
visit the Search Press website for
details of suppliers:
www.searchpress.com

You are invited to visit the
author's website:
www.carolemassey.com

Printed in Malaysia

Acknowledgements

My sincere thanks to my editor, Edd, and to
Roz and all the lovely team at Search Press. A
huge thank you to all those who have provided
inspirational reference for this book: including
Alexandra, Alf, Ali, Ann, Ann and Stewart, Ben
Linzi, Bob, Bridget, Charity, Christa, Don, Elsie,
Fan, Fergus, Louis, Hannah, John, John M,
Marilyn, Molly, Nat, Natalie, Niel, Roger, Sam,
Sara and Rosie, Stewart, and Tor. Also to Charity,
Cora, Ella, Eric, Henrietta, Lorraine, Phil and
Roz for their photographs of faces from the Far
East, Middle East, Brazil, Kenya and Gambia.

Front cover
Alexandra
Charcoal (left), pencil (right)

Page 1
Bashir
Pen and ink.

Page 3
Natalie
Pastel pencil.

Opposite
The Pineapple Lady, Cuba
Pencil.

Contents

Introduction 6

The history of portrait drawing 8

Materials 10

Shading techniques 20

Structure 22

Proportions 26

Features 32

Capturing a likeness 42

Sam 48

Character and expression 52

Moving on 58

Rosie 64

Drawing from life 68

Composition 74

Story 78

Maasai Warrior 84

Age 88

Cora 90

Self portraits 94

Experimenting 95

Index 96

Introduction

Without help or direction, a child's natural instinct is to draw their immediate environment and the people most important to them. Invariably those early scribblings are intuitive creations, not attempts at a likeness but symbolic representations – and that is how we all started. The portraits we expect to produce in later life are far from these naïve beginnings: drawing the complex shapes and angles of the head, learning the disciplines of perspective, creating light and shade and grasping the importance of the negative shape, all take time, guidance, experience... and perhaps most importantly, practice.

Those who have the ability to draw a portrait or achieve a convincing likeness are often perceived as having a special talent. However, I believe that it is really a question of how you see, as much as what you see. It is simply a question of training your brain to translate the information from the eye faithfully onto a suitable surface. Seeing the head in terms of abstract shapes and patterns aids this analytical process.

Thankfully, there are many techniques to aid our perception and help us evaluate these intricacies. My aim is to demystify the whole process of drawing people and help both the beginner and more experienced artist to gain confidence through a simplistic approach and careful observation using pencil (graphite), charcoal and pen and ink. The book examines materials, shading, the proportions and features of adults and children, hair, facial hair and clothing, poses, composition and lighting as well as showing several step-by-step demonstrations.

Portraiture, like any other skill, demands 'practice, practice, practice', so try to draw whenever possible. Keep a sketchbook to improve your observational skills; if you wish to work from life and cannot find anyone to sit, then try a self portrait – either using one or two angled mirrors.

Sketch presenters or interviewees on television: it is fun to examine familiar faces to determine just what it is that gives an individual their character.

Working from life is not always possible or practical, though it is certainly the best way to understand the character of your sitter, contributing that essential and indefinable 'something' which will give life and vitality to your work. Many of the examples in this book have been created using my own photographs in addition to sketches, which I have done from life. When you begin drawing portraits, working from photographs is probably easier, the image having been reduced to two dimensions already. Try to take your own photographs – this way you will have met your model, and know something of their character. When you have gained confidence, try to work from life as well, as it is extremely good practice.

My interest in portraiture began over thirty years ago when I was encouraged by a friend to attend evening classes. Although I had done a lot of life drawing at art school, portraiture was not included and I found the experience of drawing and painting from life tough yet intriguing. Since then I have produced many portrait commissions, in pencil, charcoal, ink, pastel, acrylics and oils.

Whether young or old, the human face continues to challenge and captivate. It is probably the most demanding of drawing disciplines, yet for me, the most gratifying. I hope you will be inspired by this book and come to share my enthusiasm for this stimulating subject.

Opposite:
Molly
A pencil study made from life. Inset at the top left are the initial stages of the drawing.

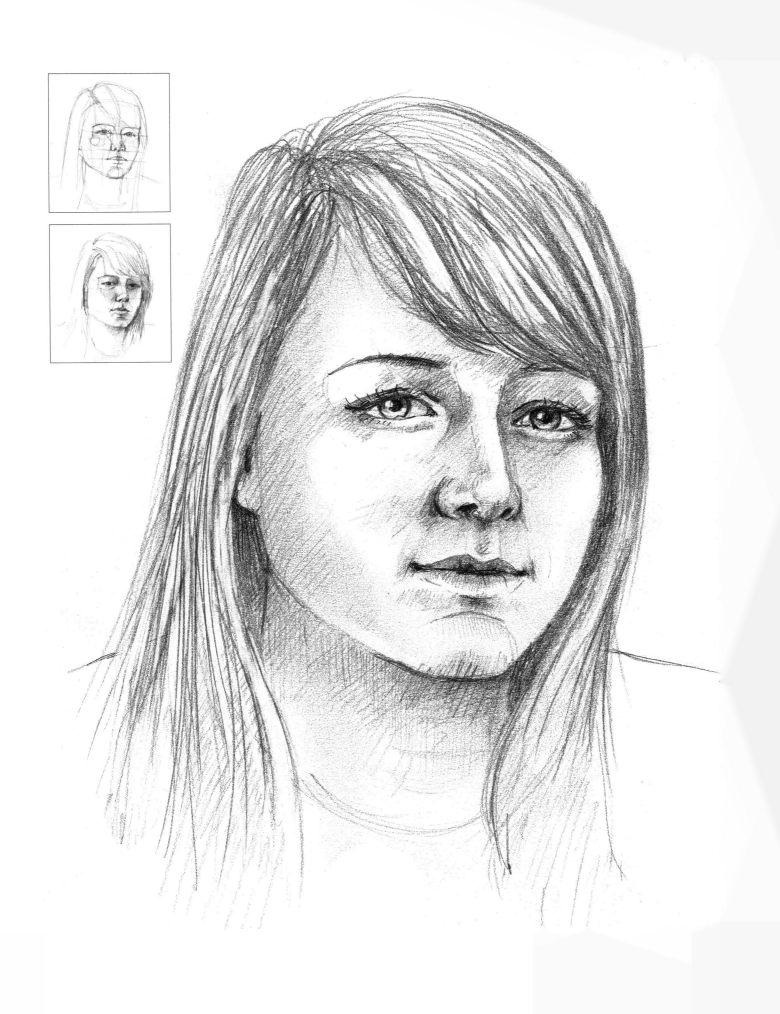

The history of portrait drawing

Study of Elizabeth

Leonardo da Vinci was a master of sfumato, *a technique of soft, blended shading that allowed his figures to emerge from the shadows. Although he produced relatively few paintings and lived over five hundred years ago he is still one of the best-known artists in the world.*

Portraiture as we know it was introduced 2,500 years ago by the Greeks. They aimed for perfection rather than accurate representation, and their sculptures depicted perfectly-proportioned, aesthetically pleasing superhuman figures rather than real people. In the second century BC, the demand for portraiture grew as wealthy Romans commissioned portraits to boost their social status. They required enough realism to make the portrait recognisable so sometimes a lifelike 'warts and all' portrayal was placed atop a beautifully stylized, flattering torso.

Portraiture declined with the demise of the Roman Empire. Artists in the Middle Ages were more concerned with creating iconic images glorifying God rather than representing their fellow man. Art was stylised and symbolic. It was not until the Renaissance that portraiture once again emerged as an important art form, and as artists depended on the support of wealthy patrons, figures in religious paintings were once again modelled on real people.

The Renaissance also heralded several important developments in the art of portraiture. Flat profiles became three-quarter views and artists aimed to reveal something of the subject's personality. The use of modelling and the newly discovered tool of perspective helped to conveyed a sense of space and depth.

Paintings at this time were often in the form of frescoes: pigments applied directly into wet plaster in churches. The invention of oil-based paints in fifteenth century Europe revolutionised portraiture. Oil paintings on board and canvas replaced earlier egg tempera panels, making images more portable and allowing artwork to be viewed by a much wider audience. This innovation has been attributed to Van Eyck. Regardless of whether he was actually the first person to use this medium, his influence on the Renaissance is unquestionable. His most famous portrait, known as *The Arnolfini Wedding*, depicts a young couple standing in a formal pose, surrounded by symbolic clues to their past and future. It features rich colour, luminous detail, and subtle diffusion of light.

One of the most well-known portraits of all time is Leonardo da Vinci's *Mona Lisa* (*La Gioconda*). There is much speculation and conjecture over her identity, but whoever she was, her enigmatic smile remains as alluring and mysterious today as it was over five

centuries ago. Painted over several years (1503–6) the subtle modelling of forms, novel aerial perspective and atmospheric illusionism has inspired artists over the centuries.

The knowledge and techniques developed during the Renaissance led to more sophisticated, realistic work. Although commercial success and great wealth in cities such as Venice led to a market for portraits that were designed to flatter their patrons, artists found greater freedom in their self portraits, where we can see real expression, mood and character.

Rembrandt's many revealing self portraits trace his progress through life. The contrast between his self portrait as a young man at thirty-four and the disillusioned, weary face of a sixty-three year-old man in the year he died (1669) shows supreme skill and mastery.

We continue to revere and learn from the great portrait artists of the past: Caravaggio, Velázquez, Rubens, Goya, Dürer, Frans Hals, and Van Dyck to name a few. Whether or not they produced perfect likenesses of their subjects, their paintings still breathe a life and character of their own and what matters is that they continue to teach us the essential drawing techniques that we use today: modelling, pose, tones, and composition.

The invention of photography in the nineteenth century had a great and positive impact on portrait painting, although at the time, it was feared it would replace traditional portraiture. The impact of photography is evident in the cropped framing and intimate, casual snapshots of everyday life in the work of Courbet and Degas, who saw a new, unrelenting realism in the medium.

In contrast to this realism, artists such as Cézanne, Van Gogh, Matisse and Picasso made groundbreaking innovations in analysing colours and shadows, which gave an 'impression' of a subject – a sense of light and movement, rather than a coldly representative surface image. This paved the way for artists to paint what they felt, rather than what they saw. From Impressionism it was a short step to Cubism, Expressionism, Fauvism and ultimately Abstraction. The portrait had grown up. It had become a vehicle that revealed as much about the artist as the model.

In the twenty-first century we are free to explore every technique and format – to vault from photorealism to abstraction, from miniature to mural or collage – they are all valid directions for portraiture. Flattery and patronage in portraiture are still influential but in a curious about-turn, many respected portrait artists now have a higher celebrity status than their subjects. Furthermore, in the past decade the internet has created a global audience, and art has been taken beyond the confines of gallery walls. Our horizons are now practically limitless.

Breton Peasant Woman

Van Gogh often painted the farm workers amongst whom he lived and worked. I have used a stick and a dip pen to emulate his style of using strong lines to delineate figures and the swirling, twisting marks he used to describe the landscape.

Portrait of a Youth

This linear pencil drawing is inspired by the portraits of David Hockney. We can learn much from the way he is able to capture the character of his sitter through extreme economy of line and simple, almost minimalistic, drawings.

Materials

GRAPHITE PENCILS

Pencils are the most frequently used, economical and readily available drawing medium. Made of a graphite core encased in a wooden shaft, they are available in a wide variety of shapes, sizes and degrees of hardness or softness, ranging from 9H (very hard) to 9B (very soft). The choice of style and softness will depend on personal preference.

Graphite pencils For portrait work, I usually use 2B and 4B pencils.

Propelling pencils These have a fine lead and do not require sharpening. Some have a small eraser at the end, which is very convenient. I use sizes 0.5mm and 0.7mm.

Carpenter's pencils The flat, broad lead of this type of pencil allows you to create both fat and thin lines.

Graphite sticks, and **progresso pencils**, can be used for large work where greater coverage is required.

Chinagraph pencils Made from hardened black wax, these create a soft, dark mark which cannot be erased easily.

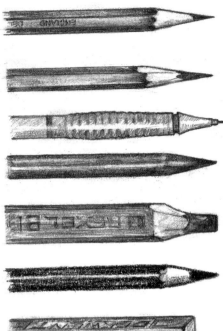

Top to bottom: graphite pencil, graphite pencil sharpened with a knife for a longer lead, propelling pencil, progresso pencil, carpenter's pencil, chinagraph pencil, graphite stick.

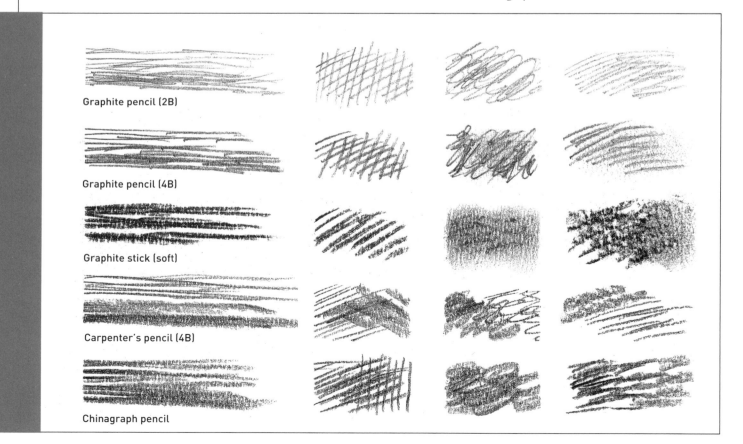

Graphite pencil (2B)

Graphite pencil (4B)

Graphite stick (soft)

Carpenter's pencil (4B)

Chinagraph pencil

Laura

Drawing the hair was fun; after creating an overall dark grey tone with a graphite pencil by drawing and smudging, I shaped a kneadable eraser to a point to 'draw' in the highlights, then used it with a dabbing action for the softer highlights on the cheek.

CHARCOAL AND RELATED MEDIA

Willow charcoal is a traditional medium produced by the slow burning of wood to create pure, natural sticks available in widths from 2mm (¹⁄₁₆in) to more than 10mm (³⁄₈in). Fine lines can be produced using the tip of the stick while broad sections can be blocked in using the side. It can be blended or smudged effectively with a finger, tissue, cotton bud or torchon to create a wide range of tones. Highlights can be lifted out easily with a kneadable eraser.

Compressed charcoal This is less smudgy than willow charcoal and is available in both stick and pencil form in a variety of grades. I prefer the stick form which delivers a rich, intense black.

Charcoal pencils These provide a more convenient, cleaner way to use charcoal. They are available in a range of dark greys and blacks.

Carbon pencils These are made from a mix of charcoal and graphite.

Conté sticks A harder and slightly waxier type of charcoal medium, these are formed into square sticks; using the tip will give a clean, hard line whereas the side will produce broad dark marks. They are made in a range of earth colours – brown, sanguine as well as black and white which I find very suitable for portrait work.

White pastel pencil These can be used for adding highlights on tinted pastel papers.

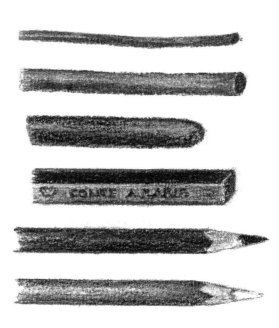

Top to bottom: 2mm (¹⁄₁₆in) willow charcoal, 6mm (¼in) willow charcoal, compressed charcoal, conté stick, charcoal pencil, white pastel pencil.

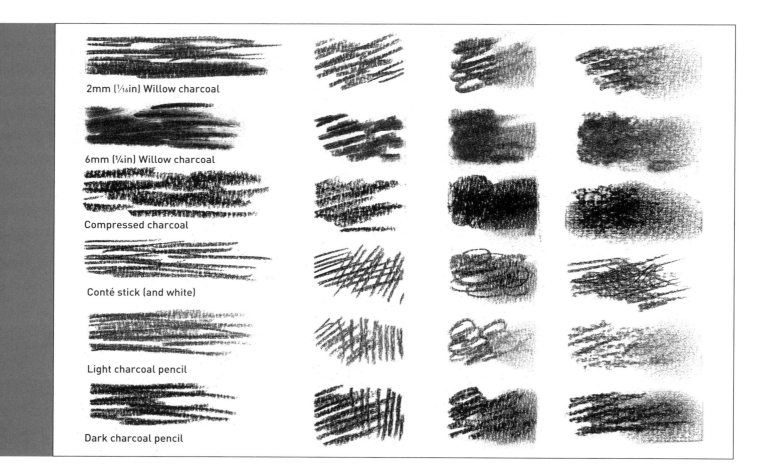

2mm (¹⁄₁₆in) Willow charcoal

6mm (¼in) Willow charcoal

Compressed charcoal

Conté stick (and white)

Light charcoal pencil

Dark charcoal pencil

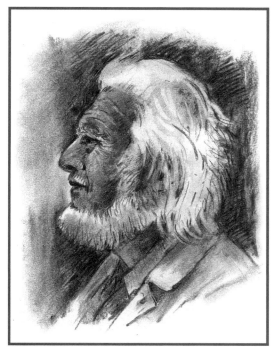

At the Fête, Moncontour

I spotted this man with his wonderful shock of white hair and matching beard at a local fête. Willow charcoal was the ideal medium for this tonal sketch. I used a thin stick to sketch in his profile, then blocked in the background and dark areas using the side of the stick, which I smudged in with my finger. I redefined details with the tip of the charcoal and used the eraser to draw finer white areas, adding sufficient detail without overdoing it.

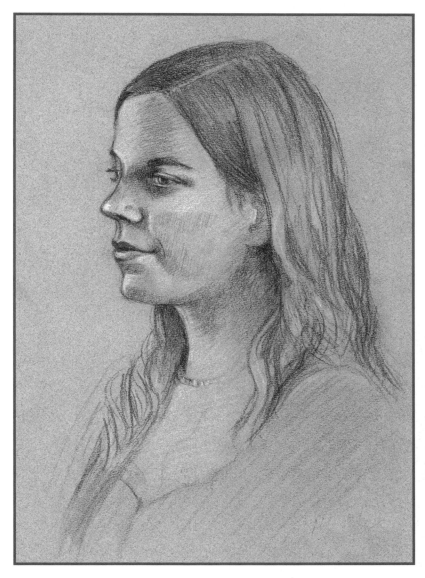

Hannah

I sketched Hannah from life, working in pastel pencil on tinted paper. As it was virtually a profile view, I could only partially see the eyelashes and highlight in the far eye. Having placed the features lightly, I put in the highlights with a white pastel pencil before starting to do any shading and allowed the natural tone of the paper to suggest a mid tone, particularly in the hair.

PEN

Pen produces a clean, permanent mark. Tones are created using a series of parallel (hatching and cross hatching) or curved lines, dots, scribbles or other suitable marks. A smooth or medium surface paper is therefore best for pen work. Because you cannot erase these marks, using pen can be a bit scary. However, a deliberate, indelible mark can create a more lively and dramatic drawing.

Dip pen The nibs of dip pens are made in a range of shapes and sizes which are fitted into a holder and used with Indian ink, for example. The mark produced has character and variation, thickening as more pressure is applied to the nib.

Fibre-tipped pen These are clean to use and produce a line of constant width, 0.2–0.7mm being most suitable for portrait work. They can be permanent or water soluble.

Technical pens (not shown) Harder wearing but more expensive than fibre-tipped pens, these have a metal tip. They produce a constant line which varies according to the size of nib; 0.1mm is extremely fine, while 0.9mm is thicker. They have a refillable cartridge.

Brush pens These have a nylon or fibre brush which is supplied with a constant flow of ink from the cartridge. A wide range of brush-like marks can be achieved from very fine to thick.

Other pens Ballpoint, fountain, calligraphic and double-ended water-soluble pens are also suitable for drawing portraits, depending on your own preferences.

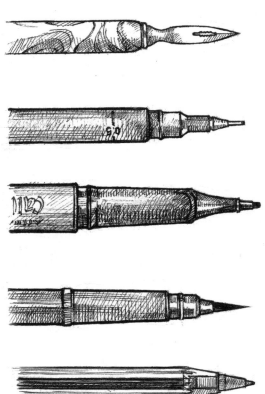

Top to bottom: dip pen, fibre-tipped pen, thick fibre-tipped pen, brush pen, ballpoint pen.

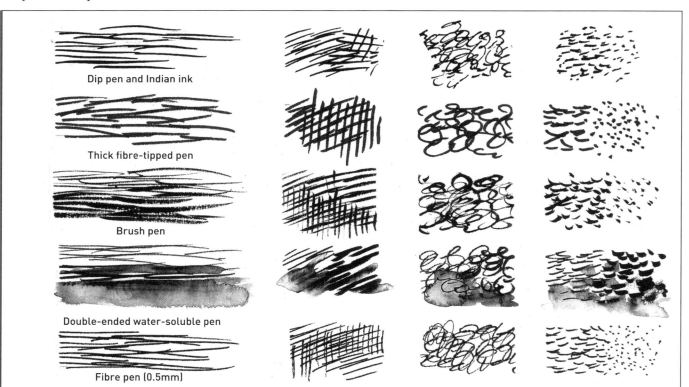

Dip pen and Indian ink

Thick fibre-tipped pen

Brush pen

Double-ended water-soluble pen

Fibre pen (0.5mm)

14

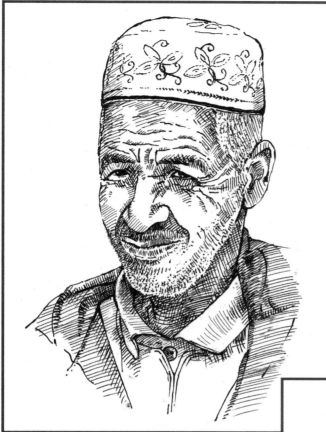

The Old Potter, Marrakech

We received marvellous hospitality from this lovely old man and his family while on a painting trip to Morocco. I did some sketches and took photographs of him which I have used for this pen drawing. I sketched the features in pencil on cartridge paper before starting the drawing proper with my dip pen and Indian ink. I built up the tones using a wide variety of marks – dots, hatching, cross hatching, and broken lines, being economical with the coverage. The maxim 'less is more' applies well here. Pen lends itself readily to a face with character but I feel it would usually be too harsh for a child's portrait.

African Girl

Using a brush pen on cartridge paper, I drew this portrait without any preliminary pencil work. I plotted the features and established their position with a series of dots. When I was happy with the proportions, I carefully drew the portrait, paying close attention to my reference photograph, noting the negative shapes and the structure of the head. While the ink was still wet, I added water to brush in some midtones. This study took about fifteen minutes.

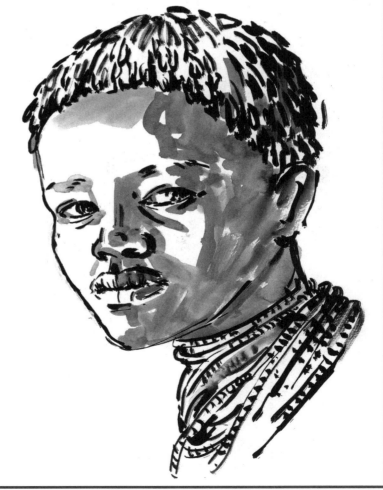

SURFACES

A wide variety of papers is available that are suitable for drawing. Inevitably it comes down to a matter of personal choice.

Cartridge paper This is made in a range of finishes and weights. For pencil and charcoal, the paper needs to have a texture with a slight 'tooth'. The weight is measured in grams per square metre (gsm) or pounds. I prefer to use medium surface paper of at least 150gsm (70lb) weight, which is suitable for pencil, charcoal or pen, and will also withstand a light wash. Rough surfaces give a broken effect and therefore are not so suitable for pen and ink unless texture is desired.

Pastel paper As well as being available in a wide range of colours, pastel papers also have 'tooth'. Some have a smooth and a rough side, and the choice of texture may depend upon your subject. For the delicate complexion of a child I would select the smooth side (see *Rosie*, pages 64–67), whereas I might decide on the rougher side to create more character for an older person (see *Glaring*, page 56). A midtone is most appropriate for portraiture so that both black and white pastel pencils contrast with the surface.

Watercolour paper (Not) This is a semi-rough watercolour paper (see below). The surface can be used for charcoal and pencil, giving a very grainy quality to the drawing.

Watercolour paper (Hot-pressed) Also known as HP or smooth, this paper is suitable for pencil or pen work.

Tip

Before starting to work on pastel paper, check you are using the appropriate side (smooth or rough). It is not always obvious until you start to block in the tone; by then you may have already spent some time working on the 'wrong' side for your particular subject!

John

This sketch, in black and white pencil, was done from life on the textured side of a mid-grey pastel paper.

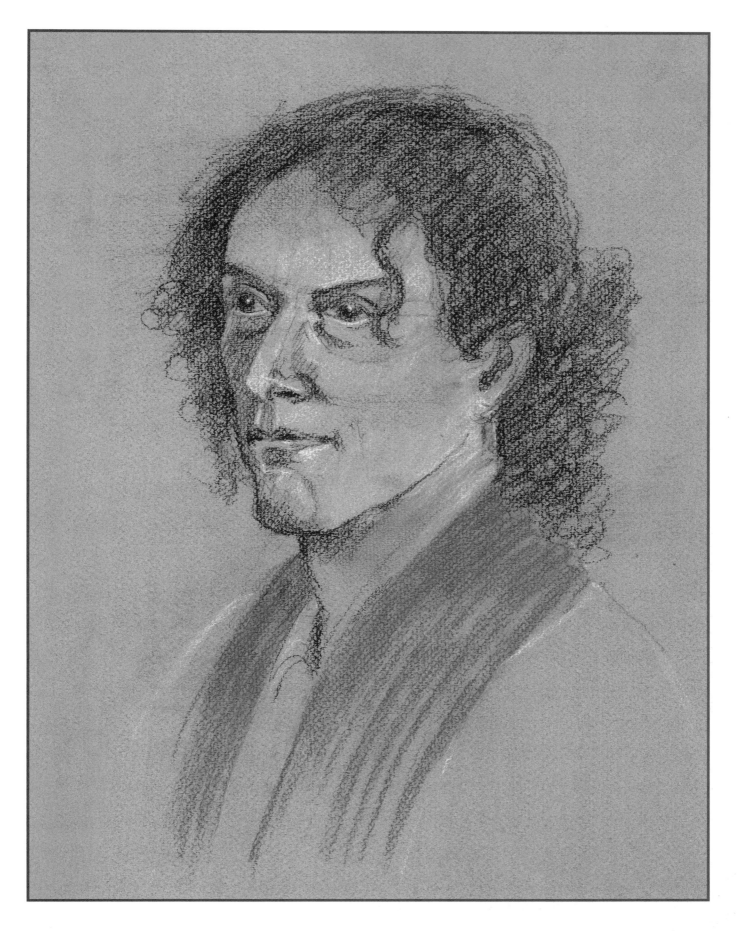

OTHER MATERIALS

Tracing paper This is semi-transparent paper used for tracing photographs or drawings.

Transfer paper A type of tissue paper that is impregnated with graphite on one side and used to trace down an image. I call it 'artistic carbon paper'.

Camera I find that a camera is extremely useful for recording details of poses. My digital camera is invaluable when working on portrait commissions in particular as it enables an instant review of images.

Viewfinder This simple card frame is a very helpful aid to decide on the composition, whatever the subject. I often use the 50 x 75mm (2 x 3in) aperture as a template for thumbnail sketches.

Drawing board A firm surface on which to draw is an essential studio item. Raise the head of the board to a comfortable working position or use it upright on an easel.

Clips A simple and reusable way of fixing your paper to the board. Also handy for clamping sketchbook pages down if you are sketching outside in windy conditions.

Fixative Useful for helping to 'fix' charcoal or pastel. It can, however, dull highlights and will not entirely prevent smudging.

Masking tape Always fix your paper to the board to prevent it moving while you work.

Erasers

- Kneadable erasers are made of soft, malleable material like putty. It can be shaped to a point for erasing highlights in pencil or charcoal.

- Plastic erasers are a harder type, suitable for erasing more durable marks.

- Electric erasers are surprisingly useful for erasing small areas in pencil or charcoal, for example, a tiny highlight in the eyes or wisps of hair etc.

Torchons (stumps), cotton buds Torchons are very tightly rolled batons of paper with pointed ends, available in a variety of sizes, used for blending and smoothing pastel or charcoal. They can be cleaned with sandpaper or a sandpaper block. Cotton buds can also do this, though are not as fine.

Sandpaper block Very useful for honing a pencil or pastel pencils to a point between sharpenings. It can also be used for cleaning torchons.

Pencil sharpeners

- A manual pencil sharpener is a practical and safer alternative to using a craft knife for keeping your pencils sharp.

- An electric pencil sharpener can save a lot of time and effort if you have a large quantity of pencils to sharpen. It can take a variety of pencil diameters.

Craft knife In my opinion this is the best way of sharpening a pencil to a long, fine point, but not everyone finds this easy or safe.

Shading techniques

Shading creates tone and 'form', making the flat two-dimensional surface appear three-dimensional. It is usually added after the outline drawing stage of the portrait has been completed. The lines, marks or areas of shading should be built up slowly and systematically, serving to enhance what is there rather than be intrusive.

HATCHING AND CROSS HATCHING

Hatching creates shading using a series of parallel lines; how close or far apart they are will determine the degree of tone. They can describe a small detail or cover the whole side of the head to harmonise a larger area. The lines can be applied in any direction, and can be used to suggest the contour of a particular feature or plane.

Cross hatching is added over hatching lines, usually at a slightly different angle to the initial hatching lines (see examples opposite). Several layers can be added, altering the angle each time to create a really dark tone.

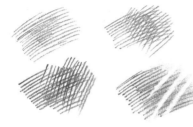

Examples of hatching and cross hatching using 2B (left) and 4B (right) graphite pencils.

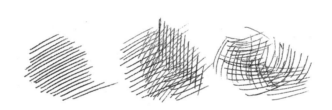

Examples of hatching, cross hatching, and swirling marks in pen and ink.

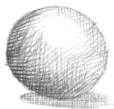

An example of contour hatching: the lines are curved to accentuate the shape of a form.

STIPPLING

A series of dots or dashes used with pen and ink, where a greater variety of marks is required to create texture and tone.

SMUDGING

Smudging pencil, pastel and charcoal is an effective way to tone a large area. You can use a tissue, your finger or a torchon. Highlights can be 'lifted out' or erased from a dark background with a shaped kneadable eraser or an electric eraser.

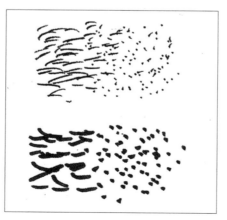

Examples of stippling. Note how adding more closely-packed dots allows you to create deeper shades and suggest shape.

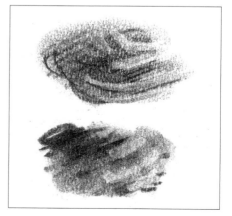

Examples of markmaking and smudging using 2mm (1/16in) and 4mm (1/8in) charcoal sticks (top and bottom, respectively). The lighter marks were lifted out with a kneadable eraser.

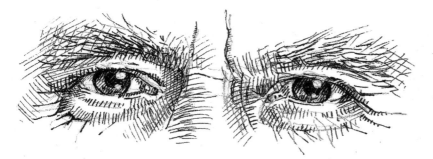

Hatching and cross hatching with a fibre-tipped pen creates hard lines, reflecting the age of an older gentleman. The lines go in a variety of directions, suggesting tough, weather-beaten skin.

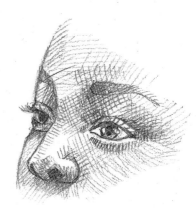

Lighter lines of hatching that follow the same direction, worked in graphite pencil, make for a more delicate appearance to this young girl.

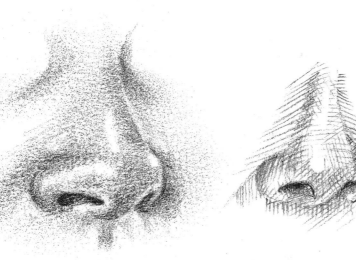

The soft shading on this baby was made with a chinagraph pencil, emphasising the delicate nature of the subject.

Tip

Many other marks can be used for shading. How you choose to interpret a particular texture or surface depends on the type of portrait and no doubt with practice you will develop your own intuitive shorthand.

This very soft shading effect was produced using a graphite stick. The highlights, which give definition to the shape, were lifted out with a kneadable eraser.

After lightly drawing the shape of the nose with a 2B pencil, I built up the shading with hatching and cross hatching lines worked in different directions, to create a three-dimensional feel to the structure.

Black and white pastel pencils were used for this study on grey pastel paper. After establishing the shape of the mouth, I added the highlights with the white pencil before switching back to the black one to add depth and tone, dotting in the stubble on the top lip with the tip of the pencil.

Structure

No matter how well each individual feature is drawn, this will count for nothing if we have not understood the overall structure and framework. The features are an addition to this vital scaffolding. If a tree or piece of fruit is drawn slightly wrong, does it really matter much? Yet the slightest misplaced line on a portrait – an eye too big or the nose a little too short, will certainly change the look completely.

THE SKULL

If you can study and draw the skull, you will have a much better understanding when you come to draw a portrait. It is easy to get so engrossed with the surface features and achieving a likeness that one forgets about what is underneath.

The form of the face and features depends greatly on the shape of the underlying skull and bones; knowledge and familiarity of this structure will help you understand and create better portraits. Because of the relatively thin covering of soft tissue and muscles, facial features are very much dictated by the shape of the eye sockets, the brow ridge, the cheekbones, the jaw and the teeth.

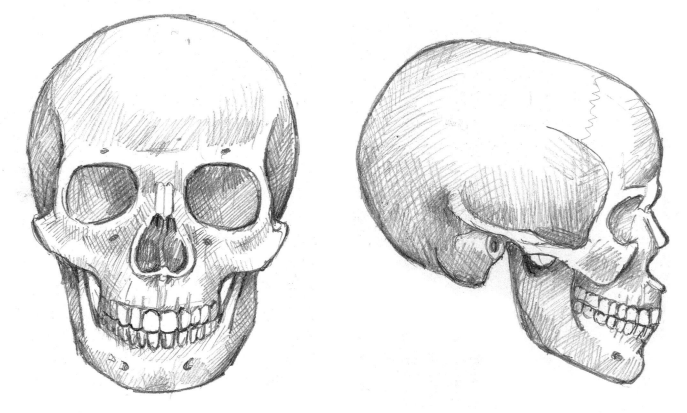

Viewed from the front, the skull is roughly an ovoid shape (left) and a 'D' shape in profile (right). Studying this bony structure, whether from a real skull or a good model, will bring a deeper understanding when you draw a portrait. As well as the eye sockets giving depth to the brow and form to the cheekbones, the teeth very much dictate the shape of the mouth. You can also see the marked turn of direction from the brow to the temples and side of the head.

BOX SHAPES

The usual way to start drawing a head, particularly from a straight on view, is to sketch an ovoid shape, but after looking at the skull we can see that the head, seen from a three-quarter view, also has a distinctive box-like structure with a front, two sides and a top.

Viewing the head as a cube serves to show us the noticeable turn of plane from the forehead to the temple, from the cheek to the side of the face and therefore helping us to draw the head in perspective. Each of the examples below illustrate how abstracting the head to a simple box shape can help with accuracy and positioning.

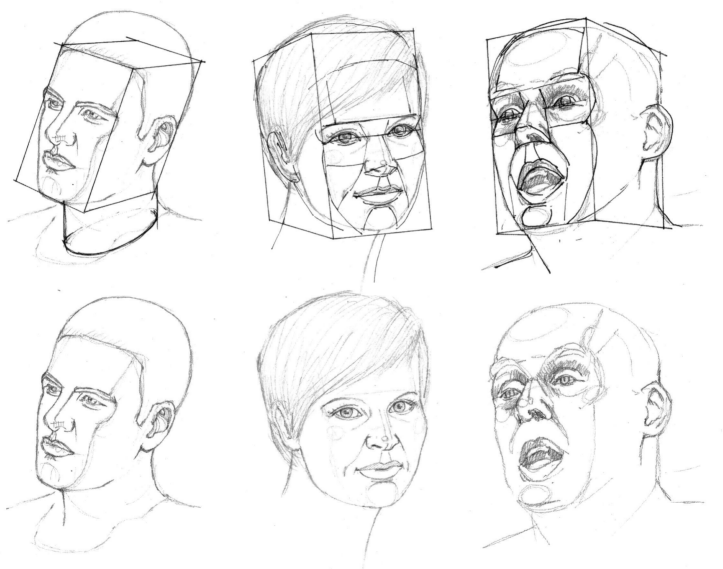

The head and neck are simplified to a simple cuboid and tube in this example. Note how important the angle of the head is in capturing the pose.

Cuboids provided a helpful basis for each of these portrait sketches. With the structure in place, it is easier to draw the features using basic geometric shapes before developing them into a finished portrait.

PLANES OF THE HEAD

Many areas within the face can be simplified into flat planes. The forehead and temples, the sides of the face and nose, the upper lip and the chin are good examples. In contrast, areas such as the lips and nostrils have more rounded contours.

The shape and angle of the flat planes can help when analysing the form of the head and defining where shadows and highlights fall. All these elements contribute to a likeness.

In these drawings I have emphasised the construction lines which show each change of angle on the surface of the face. Although not aimed at realism, constructing the head this way is a step towards simplifying form and helps to analyse the overall structure of the head.

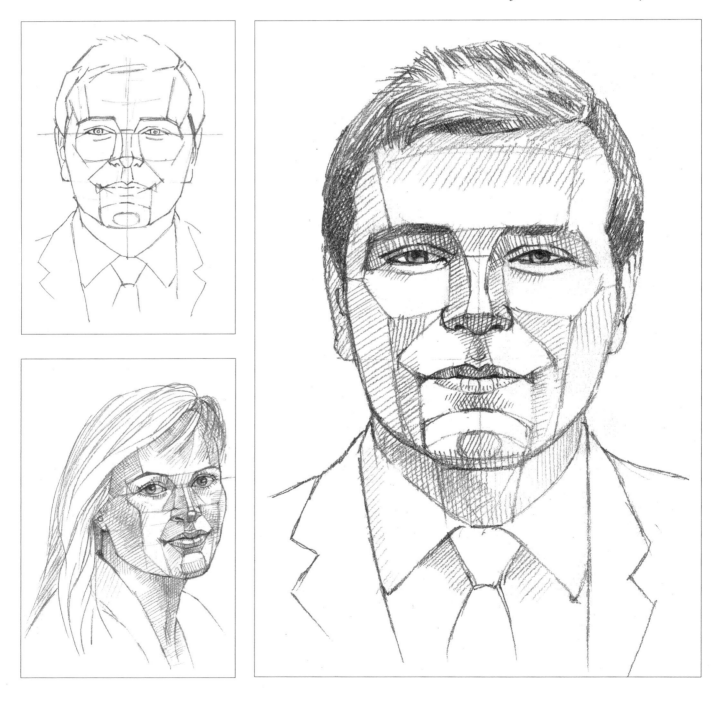

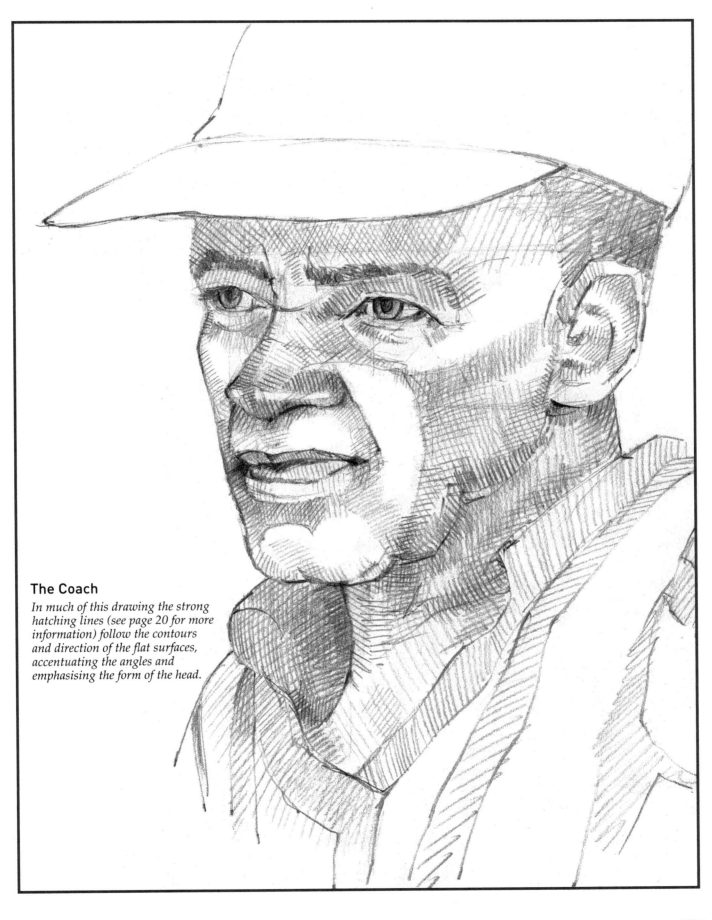

The Coach

In much of this drawing the strong hatching lines (see page 20 for more information) follow the contours and direction of the flat surfaces, accentuating the angles and emphasising the form of the head.

Proportions

We can look at someone and decide they have a long face, wide cheekbones, big eyes, a long chin or a broad nose. Faces vary hugely depending on generic differences and ethnic origins. Nevertheless there are general guidelines in facial proportions that can help the portrait artist to place the features correctly. Note that the features occupy a relatively small area of the whole head.

PROPORTIONS OF THE ADULT HEAD

- In a straight-on view, the eyeline is midway between the top of the skull and the base of the chin.

- The width between the eyes equals the width of the eye; tear duct to corner.

- The width of the eye is equal to the distance from the outer corner of the eye to the side of the head.

- The width of the nose is usually the same as the distance between the eyes.

- The mouth is usually no wider than the distance between the pupils

- The ears align with the outer corner of the eyebrow and the base of the nose.

- In profile, the depth of the head is equal to its width.

The female head is smaller than the male head, but the proportions apply the same.

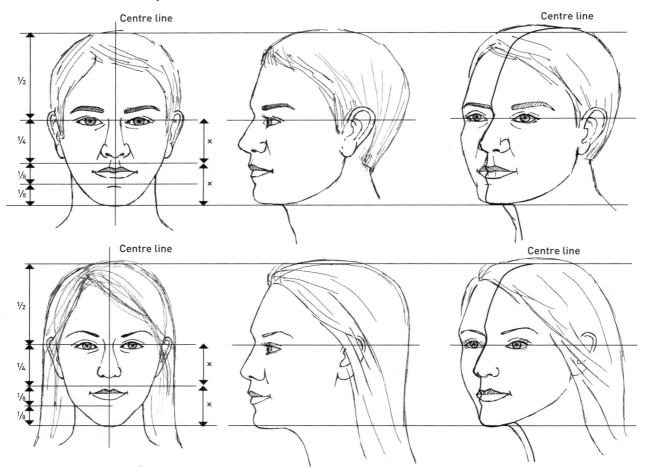

The facial proportions of an adult male and adult female in full face, profile and three-quarter views.

ADULT PROPORTIONS

Brian

This study in 4B graphite pencil, shows the sitter straight on. His face is quite round and full. The cheekbones are not apparent but highlights nevertheless indicate the change of plane from the front to the side of the head.

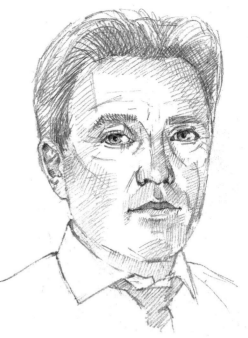

John

In contrast to the image to the left, the underlying bone structure of this man is quite obvious.

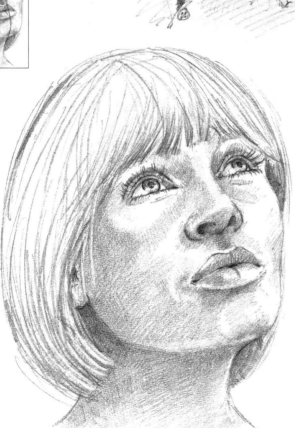

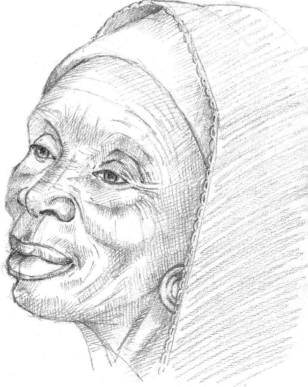

Looking Up

The eyeline is tilted quite sharply here; in this angular view it is easy to draw the nose and mouth out of alignment. Adding the vertical axis (see inset), will help the to align the features accurately.

Gambian Elder

This three-quarter view with sharply defined cheekbones, deep-set eyes and full lips, makes for an interesting, if complex, portrait.

PROPORTIONS OF A CHILD'S HEAD

In comparison to an adult's head, the following applies:

• The eyeline is below the halfway point, the cranium being much bigger.

• The eyes are wider apart.

• The nose, mouth, (and jaw bones and teeth) are much smaller.

It is important to get these subtly changing proportions right according to the age of the child.

• There are no hard lines.

• The eyebrows are sometimes insignificant.

• The hair is very fine.

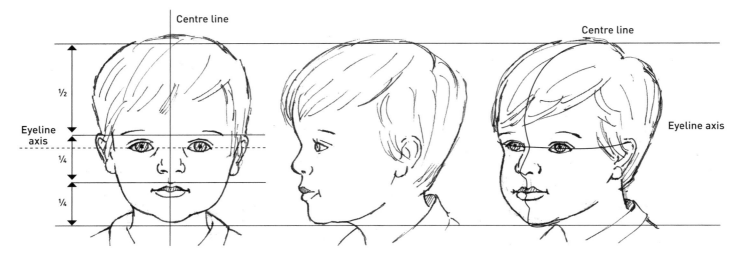

The facial proportions of a two-year-old child in full face, profile and three-quarter views. The head is approximately half the size of an adult's head.

Opposite, clockwise from top left:
Girl (8 years)

This viewpoint is quite challenging but using the eyes/nose triangle system (see page 42) simplifies the process. Her cornrows hair style, which needed precise drawing, exaggerates her high-domed head.

Boy (6 years)

This young Peruvian looks up to the camera. His eyes are large and you can see that from this viewpoint they are asymmetrical.

Girl (12 years)

Facial proportions are still developing at this age. They are far from those of an adult and she is still very childlike.

Boy (8 years)

Although the features are changing and the eyebrows more obvious, he still looks boyish.

Baby (9 months)

Wide eyes, a small nose and mouth and large forehead are typical of the features of a baby.

CHILD PROPORTIONS

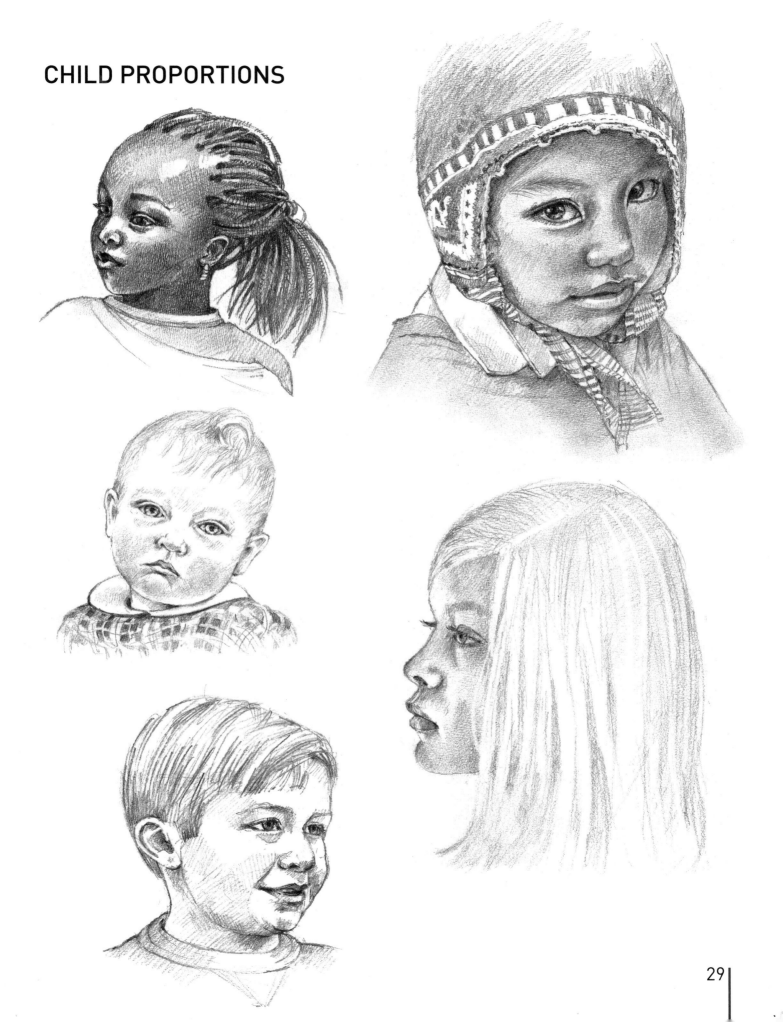

DIFFERENT PROPORTIONS

Age, gender, ethnicity and natural variation all add to the differences in people's appearance. The drawings shown on these pages illustrate faces from around the world, demonstrating the variations in proportions. Despite the differences, they all conform to the general guidelines outlined on page 26.

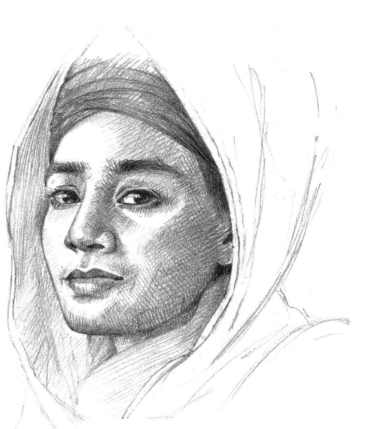

Indian Woman

This young woman looks quite determined with her long, broad nose and heavy eyebrows. Her headdress and veil frame her face, contrasting with her skin tone which I have suggested with hatching and cross hatching pencil marks.

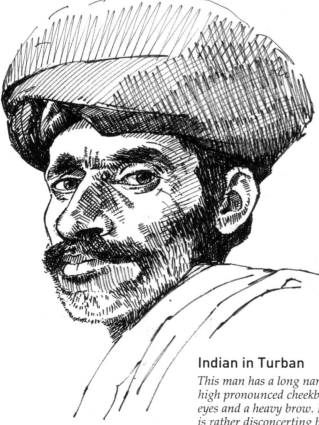

Indian in Turban

This man has a long narrow face with high pronounced cheekbones, deep set eyes and a heavy brow. His unruffled look is rather disconcerting but produces an intriguing portrait.

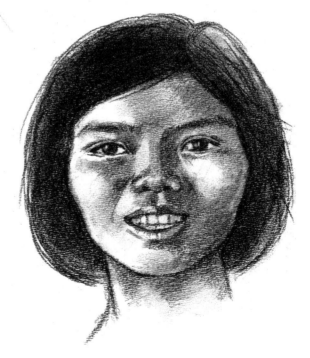

Far Eastern Woman

In this study her wide eyes tilt downwards from the corner to the tear duct. The bridge of her nose is shallow while her cheekbones are quite wide, giving a flatter feel to the face, typical of those from this region of the world.

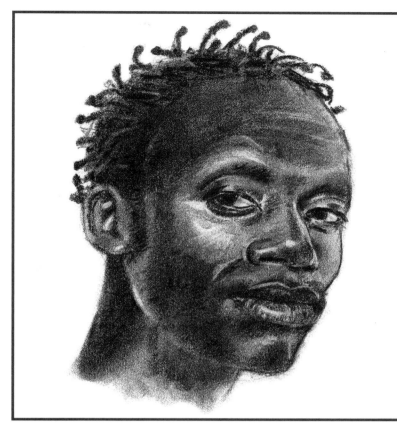

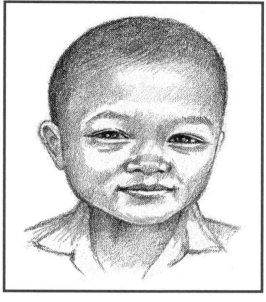

Cambodian Boy

I do not know exactly how old this boy is, but his features typically follow those of a youngster with the eyeline below the halfway point. His eyes are wide set and almond-shaped, while his nose is quite wide.

African Man

As well as a wonderful dark skin with lots of interesting highlights, this man has a strong brow with large eyelids, a wide, flat nose and very full lips. The ear, by comparison, is surprisingly small, and the hair very striking!

Afro-American Woman

Here we can see that this woman has a short nose, wide nostrils and fairly high cheekbones. Unlike an African, her lips are not so full but her hair is in very tight curls, characteristic of her race.

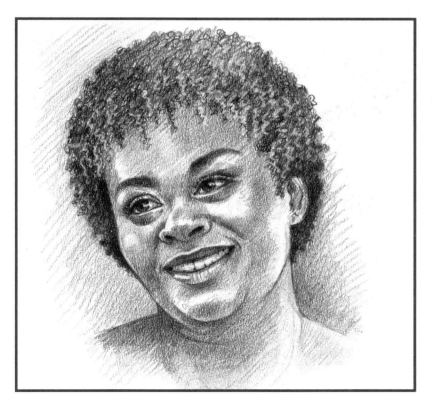

Features

Portraiture can be a complicated procedure and is often perceived as the most demanding of drawing disciplines. The many separate elements that contribute to a likeness vary a great deal depending on age, sex and ethnicity.

This section examines in detail the structure and characteristics of the eyes, the nose, the mouth and the ears of different age groups and ethnic origins. If you practise drawing individual features it will enable you to achieve better and more lifelike portraits.

EYES AND EYEBROWS

It is often said that the eyes are the window to the soul and they are perhaps the most expressive feature. It is therefore important to get both the position and the shape right. As an organ, one person's eyeballs are very similar to another's apart from the differences in the colour of the iris; it is their shape and the way they are set in the eye socket, the eyelids and the lashes that account for the huge variety. The shape and symmetry changes depending on the view and where the eyes are looking.

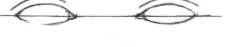

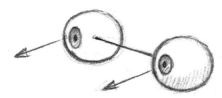

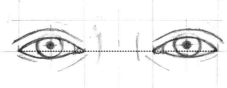

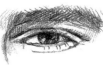

Think of the pair of spheres of the eyeballs working in unison to help avoid a boss-eyed look.

The pupils sit above a line which is drawn from corner to corner of the eyes. The upper lid is more curved (and more mobile) than the lower lid.

Look from the corners to the tear ducts, and note whether the eyes are level, or slope slightly down or up.

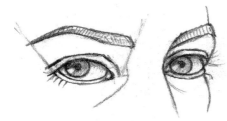

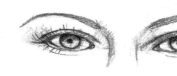

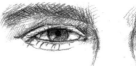

In this three-quarter view, the eyes form quite different shapes.

A woman's eyes often have long thick lashes while the eyebrows can be arched.

A man's eyebrows are heavier and thicker than a woman's.

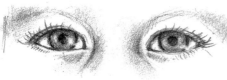

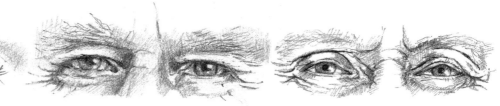

A child's irises appear bigger, and the eyes are wider apart than an adult's eyes.

In older faces, the top lid often sags and there are 'character lines' radiating from the corners of the eyes. The eyebrows are often thick and uneven. The eyelids thicken with age and less of the white of the eye can be seen.

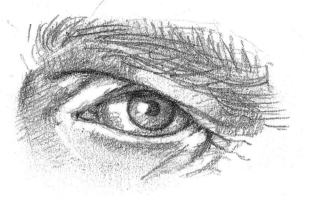

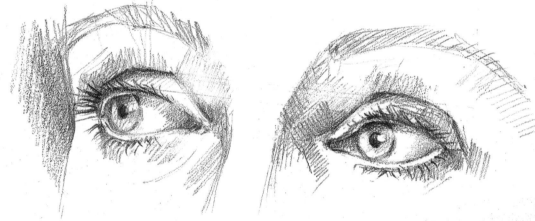

The lids often cast a shadow across the 'white' of the eye. Highlights may come from several light sources and can add a real sparkle to the portrait.

This drawing shows clearly the thickness of the eyelids, the lower one in particular catching the light. Notice how each eye varies in shape in this angled view and also the elliptical nature of the iris.

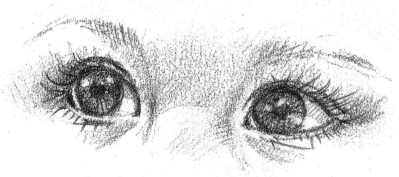

Draw both eyes when making a study. The pupils always appear in the centre of the iris even when seen from a side or three-quarter view. Note that the eyelashes spring from the edge of the lid; there is a thickness to the lid, and the bottom one often catches the light.

Exercise

Using a mirror, practise drawing your own eyes in various positions and from different viewpoints, noting how much the shape of the spheres and the eyelids change.

NOSES

The nose can vary more than any other feature and is also the most prominent feature; as such it casts more shadow – something that we often shy away from rendering truthfully.

 The upper half is shaped by the nasal bone (see the diagram of the skull on page 22), whereas the lower half is formed by cartilage and tissue and therefore more malleable. The septum is the tissue between the nostrils. Highlights and shadows describe the shape better than drawn lines, while the shadow underneath indicates how far the nose projects. It is a complex structure so the slightest change of viewpoint alters its shape.

In essence, the nose is one triangle on top of another.

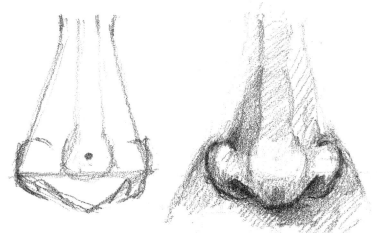

Look for the planes which will help analyse and simplify the complicated structure of the nose. The dot on the left-hand drawing marks the tip of the nose.

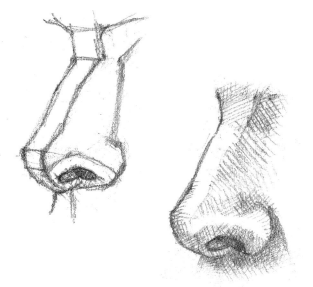

There is often a flat narrow band running down the middle of the nose which can vary in width.

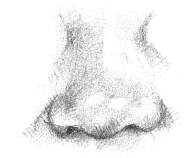

A child's nose has virtually no bridge, as this part of the nose develops as the child grows. In infants, there is no bridge to the nose at all; the nostrils and tip being the only parts of the nose that stand out.

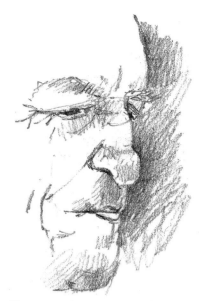

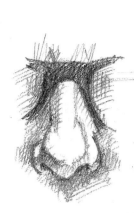
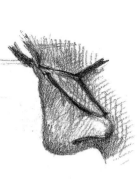
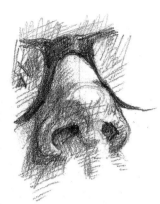

Three views of the same nose. The spectacles help to define the bridge of the nose.

Noses come in all shapes and sizes. They can add a lot of character to the face.

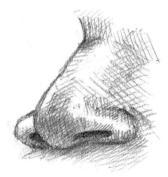
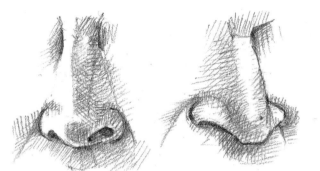
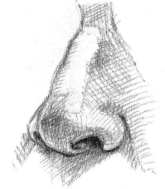

Men's noses in various shapes.

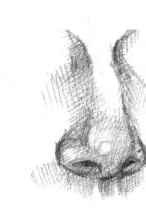
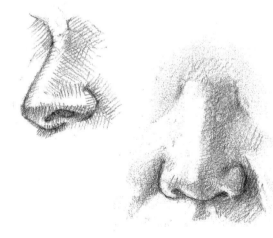

Women's noses in various shapes.

Exercise

Draw as many different nose shapes as you can. Look in newspapers and magazines for reference material, or simply sketch while you are watching the television.

MOUTH

The mouth is the most mobile of the features and consequently very expressive. The slightest change in the corners of the mouth will change the expression. The largest differences between mouths are those of race, gender and age.

The underlying structure of the teeth and the fullness of the lips give the mouth its shape. The lower lip is frequently fuller than the upper lip and may have no outline to delineate it, but instead be defined simply by highlight and shadow. Use the curving lines of the creases in the lips to emphasis the shape and form. Observe the line dividing the lips carefully, as it should be drawn sensitively.

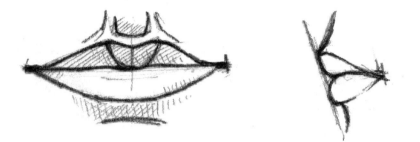

Far left: The upper lip is divided into three parts, with a central triangle forming the 'cupid's bow'. In normal lighting conditions, the upper lip is usually in shadow and therefore darker than the bottom lip.

Left: In profile, the upper lip often protrudes over the lower lip.

A selection of mouths shown face-on and in profile. From left to right: female, male, older male, child.

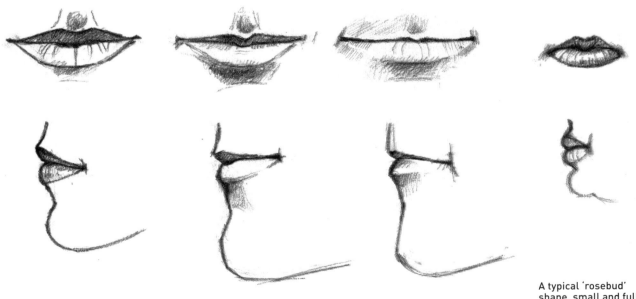

Note that the upper lip is quite thin and the lower lip is defined by light and shadow only.

A typical 'rosebud' shape, small and full.

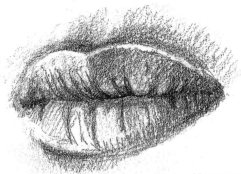

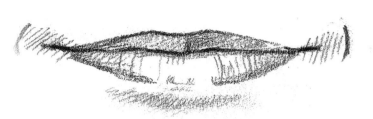

Lips vary greatly in size and thickness, depending upon the model's expression, ethnicity and facial structure.

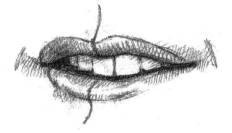

Using the central axis will help align the lips. In this example, the teeth are set well back from the lips and therefore the centre line of the teeth is set to the right.

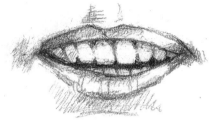

In this example, the teeth slope back, defined by the sloping central line between the front teeth.

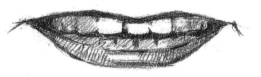

Lips become thinner with age. Sometimes the teeth are uneven or gappy, which can add to or be an intrinsic part of the character.

Teeth

It is difficult to draw a mouth showing all the teeth and in many ways such a picture is not ideal for a portrait study. Sometimes, however, a 'snapshot' composition is a memorable one. As a general rule, do not draw the individual teeth; instead, draw the gum line outline, then the outline of the top row, and the top of bottom row if they are visible. Put in the centre line of the teeth.

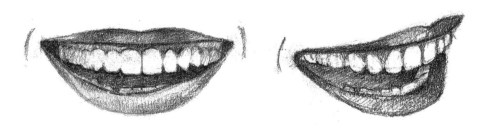

Visualise the teeth as a curved band which recedes into the cavity of the mouth, where it will be in shadow.

EARS

The ears are a feature that can often be overlooked, perceived as both insignificant and difficult to draw; but they are just as important as the other features and should be drawn with equal observation and care.

Although they vary a great deal in shape, they have the same characteristics in each person and are the same for male and female. The ears can grow and lengthen with age. This is particularly apparent in older men.

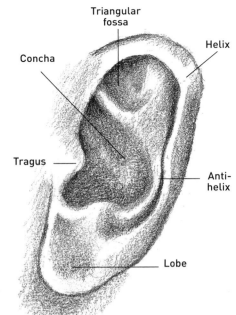

Structure of the ear

It is not necessary to learn the names of the parts of the ear but they are useful to know for identification purposes.

The helix is the outer rim of the ear, which sweeps round ending in the concha, the central concave part. The anti-helix forms an arc between the helix and the concha, meeting the tragus which can vary a lot in size and shape.

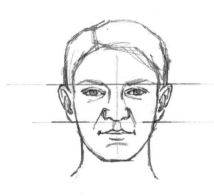

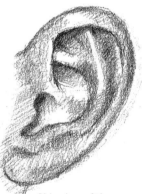

The ears roughly align with the outer end of the eyebrow and the base of the nose.

Side view of the ear.

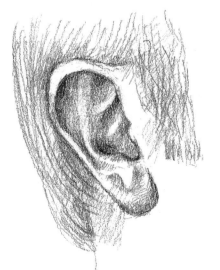
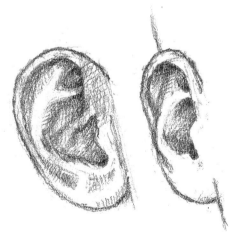
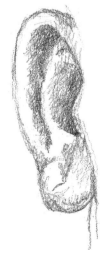

This ear has a thin helix, small tragus and a long lobe.

Different views of the same ear. In the front view (right), the anti-helix is quite prominent

This shows a larger, longer ear, typical of that of an older man.

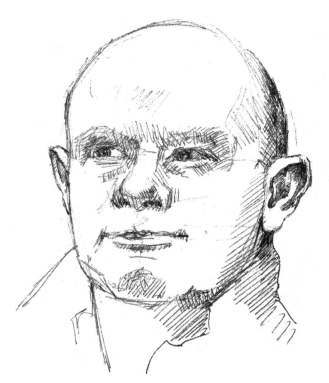

The ears can lie flat or – as here – protrude, which add to the character of the subject.

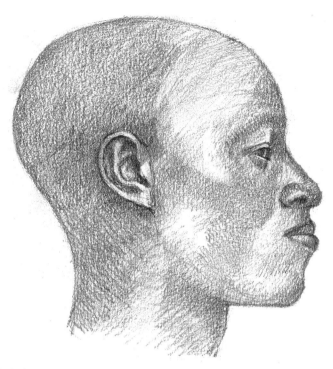

It is important to place the ear correctly, particularly in a profile or three-quarter pose. It is a common fault to minimise the distance between the ear and the corner of the eye which reduces the fullness of the skull and in turn changes the likeness.

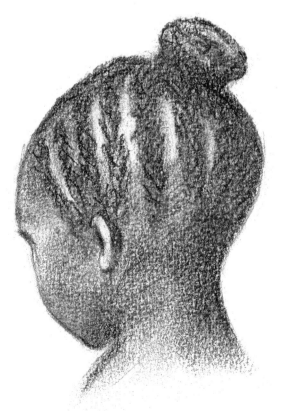

This little girl's ears seem to be a rather insignificant feature, but in fact they set the position of the jaw line and side of the head, giving shape and definition in this area.

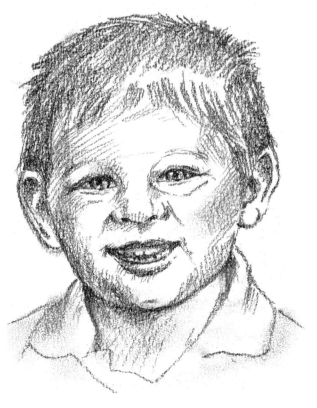

In some cases a child's ears can be quite large, proving that there are always exceptions to the rule.

HAIR AND FACIAL HAIR

When drawing the hair, treat it as a general mass, emphasising the flow and movement or texture. Drawing a few wisps of stray hair here and there can create a more natural look and if single strands or clumps stand out, draw these individually.

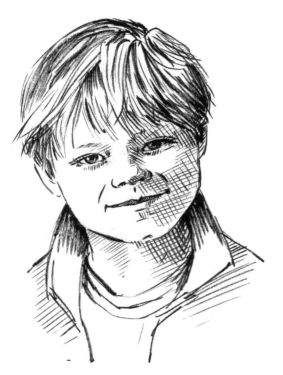

Directional marks and the varying thickness of line of the brush pen helps capture this young boy's tousled head of hair.

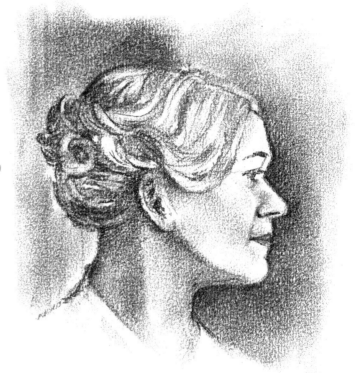

This profile view of wavy hair was rendered in charcoal, creating a smooth head of hair.

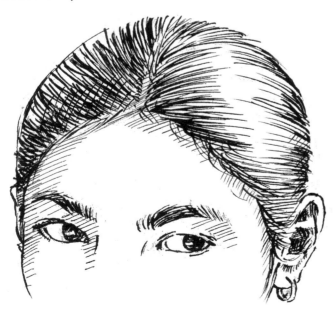

Leaving sufficient white paper between strokes of a dip pen helped to create the highlights of this dark, sleek, shiny hair.

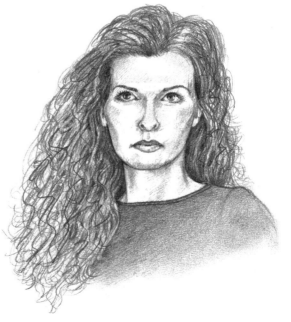

I used animated, swirling marks to draw these long, curly locks.

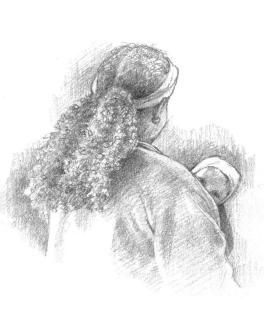

Scribbled marks made with a propelling pencil helped to create texture for this long frizzy hair.

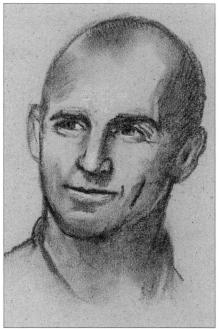

No hair! ...or at least very little. Charcoal is used to show the shape of the head where the form of the skull is very apparent.

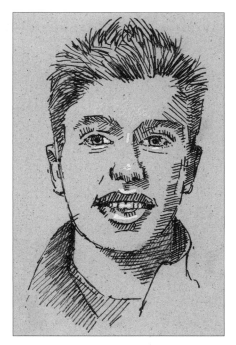

Short, straight directional marks create this youth's spiky hair style. When using felt tip pen, allow the white of the paper to show through.

Facial hair

As with hair, moustaches and beards should be treated as a three-dimensional mass. Avoid labouring over numerous individual strokes but add a few selectively round the mouth and the outer edges to add both texture and shape.

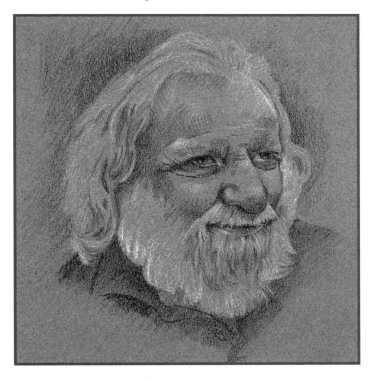

White and black pastel pencil, used sparingly, were ideal to create this old man's white hair and beard. I darkened the background behind his head to increase the contrast with his hair.

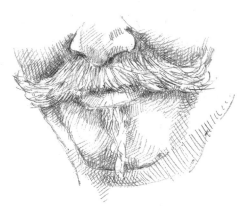

Deliberate darkening around the moustache with hatching and cross hatching marks makes it stand out and appear light. Directional curving lines imitate the growth of the hair down the centre of the chin.

Capturing a likeness

THE EYES/NOSE TRIANGLE

Any view other than full face distorts the features making it difficult to analyse what is true. Too often we draw what we think we see rather than what is actually in front of us. Once you have drawn the eye line and central axis and the eyes, you can use the eyes/nose triangle system of measuring explained here to help to establish the length and position of the base of the nose. It can also be used to fix the position of the centre of the mouth and is a method I use frequently working either from a model or from photographs.

When working from life, it is usual to work upright on an easel so that the image of the model is alongside your working surface. Hold the pencil in midair aligning it with the pupil of the eye and the base of the septum; swing your arm across to mirror this angle on the paper; repeat for the other side. Check the angles are correct by repeating the whole process.

If you are working from a photograph secured to your board, lay the pencil on the angle to be measured, then swing it across, being careful to replicate the angle. Repeat for the other side and double check your angles are correct. I prefer to draw these construction lines freehand rather than use a ruler, which I find too mechanical.

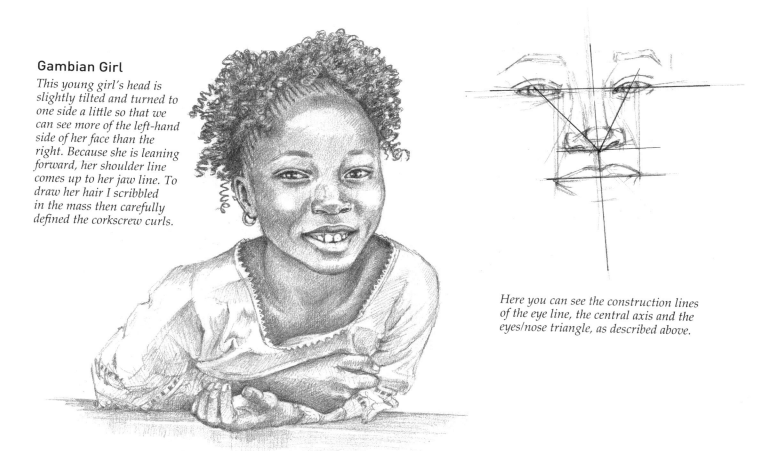

Gambian Girl

This young girl's head is slightly tilted and turned to one side a little so that we can see more of the left-hand side of her face than the right. Because she is leaning forward, her shoulder line comes up to her jaw line. To draw her hair I scribbled in the mass then carefully defined the corkscrew curls.

Here you can see the construction lines of the eye line, the central axis and the eyes/nose triangle, as described above.

Using the eyes/nose triangle

This three-quarter pose, looking slightly down at the model, is another example where I found the eyes/nose triangle measuring system extremely helpful. It is very difficult to judge the length and position of the nose without this useful technique.

Tip

Although it is good practice to draw directly in pen, if the portrait is complicated or an unusual view, it is safer to start by making a pencil drawing, particularly if you are a beginner.

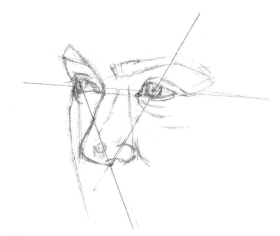

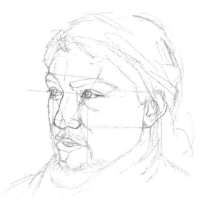

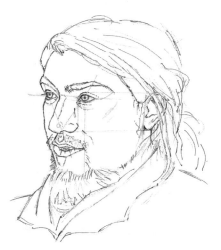

1 In pencil, draw the eye line and mark the position of the pupils. These determine the size of the finished portrait. Sketch in each eye, observing the distance between the tear ducts, the differing shapes of each eye and the negative shape between the upper lids and the eyebrows. To assess the length of the nose, draw a diagonal from the pupil of each eye to the base of the nose to form a triangle.

2 By drawing vertical lines from the eyes, I can plot the width of the mouth and then judge its distance from the nose by comparing that with a similar distance elsewhere on the head. Assess the position of the ear by measuring across to the nose and comparing that with a similar distance.

3 With the features accurately established, redraw them in ink, continually reassessing and altering where necessary. Begin lightly, using dotted and broken lines, then strengthen and emphasise the features.

The finished portrait

Shading is selectively added to complete the portrait. Less is more with pen and ink, particularly with the beard and hair. Had I drawn them as dark as they appeared, they would have overpowered the portrait. I emphasised a long, light strand of hair by darkening behind it. Having completed the drawing I erased some of the pencil lines, particularly those that interrupted the flow of the portrait.

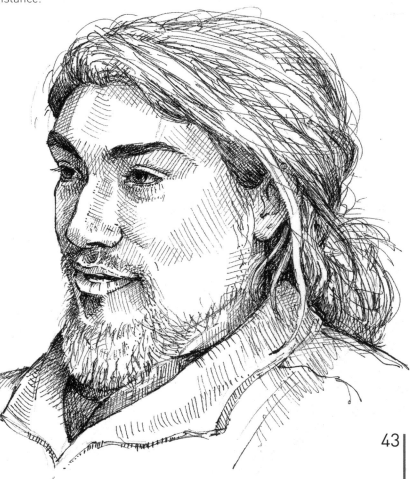

GEOMETRICAL SHAPES

Looking for the angular shapes within the head or between two figures is another way of simplifying the somewhat complicated process of drawing a portrait and getting a likeness. These thumbnail sketches show examples.

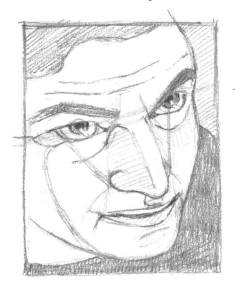 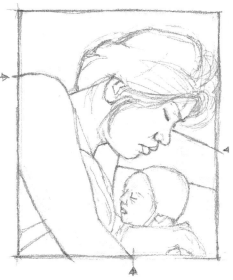 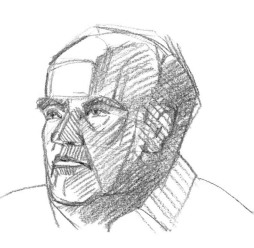

Looking Up

This unusual viewpoint can be difficult to draw. Features appear distorted from this foreshortened angle; it almost ceases to be a face and instead becomes a series of angular shapes. This makes it a challenging but fascinating subject for a portrait study. In addition, the lighting from below creates fascinating shadows and shapes that intensify the expression.

Mother and Baby, Sleeping

As well as finding this a charming subject, I loved the interplay of angular forms – the mother's arms framing and enfolding the tiny baby. As a starting point, I marked where the mother's arms dissected the edge of the photograph and blocked in the large main shapes. I drew the mother's head, and by comparison, the much smaller baby's head.

David

In the first of a number of sketches of this model, I started by evaluating the planes and geometric shapes to get to know his features and proportions and thereby achieve a likeness.

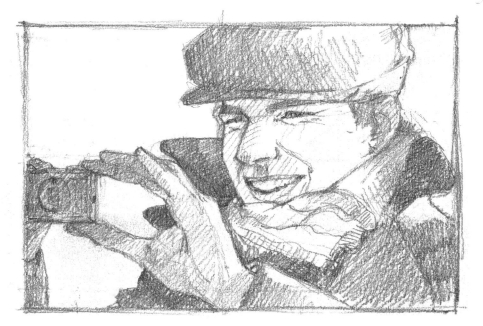

Winter Photos

This is quite a complicated subject with an intriguing interplay of positive and negative shapes (those areas between the solid bits). Analyse the main elements first – the head and cap, coat and scarf, before moving on to the hand and camera. Tonally, this sketch makes an interesting study with the contrasting light and dark areas too.

ABSTRACTING YOUR SOURCE MATERIAL

Learning to draw is a really about learning to see, training our brains to analyse what is in front of us and interpret that truthfully rather than reproduce how we think something should look. Viewing a familiar subject in a new way encourages us to analyse what we actually see rather than follow a preconceived idea. It helps us, therefore, to draw what we see and not what we think we see.

Exercise: Upside-down drawing

The aim of this exercise, inspired by the artist Dr. Betty Edwards, is to allow the right-hand side of the brain to take over from the usually dominant left-hand side. The right-hand side is the intuitive non-verbal side which thinks in patterns or pictures. It is this side which should be dominant for an accurate drawing, allowing you to faithfully evaluate angles, dimensions, shapes and patterns. The function of the left-hand side is to reduce thoughts to numbers, letters and words; it is the verbal, rational side and consequently looks at the visual world in terms of symbols – this is an eye, this is a nose etc, and can dictate the way you draw them.

Mark a rectangle the same size as the photograph on your paper, then turn the photograph upside down. Excluding all other distractions, concentrate solely on drawing the shapes you see. Do not think of it as being an upside-down version of someone you know but as a series of interesting curves, lines, and contours.

Starting at the top, work across and down, copying as accurately as possible. Do not attempt to turn the picture the right way up until you have finished.

In engaging the right side of the brain you should be unaware of the passage of time and be able to blot out sound and other distractions to feel alert but relaxed, almost trance-like. Allow fifteen to twenty minutes drawing time, then turn the paper the right way up. You will have produced an accurate drawing of the photograph, and may have surprised yourself!

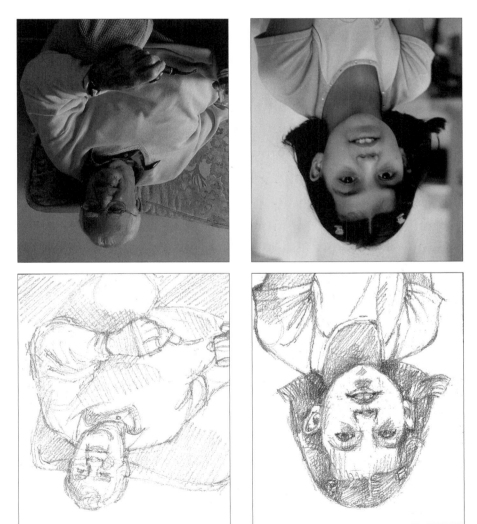

Bob with Pipe Young Israeli Girl

MEASURING WITHOUT A RULER

Judging distances and angles 'by eye' is not always an accurate method, even for the most experienced artist. The brain often challenges what our eyes see, informing us that a distance is shorter or longer than it really is. The following simple ways of measuring will help you to evaluate accurately what is in front of you and can be used for drawing any subject.

Measuring angles

Cross referencing different points on your artwork is a simple way to increase accuracy. For this process, ensure the drawing surface is alongside the model.

1 Close one eye. Holding the pencil at a right angle, align the pencil at an angle to your selected area; for instance, the outer corner of the eye to the corner of the mouth, tear duct to nostril or top of the ear to the eye.

2 Keeping the pencil at the same angle, swing your arm across to hover over the paper without changing the angle and mark that line lightly on the drawing.

3 Repeat the process to check the line you have drawn is correct.

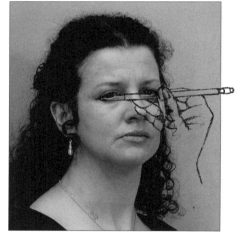

Assessing the angle of the eyeline: the tip of the pencil aligns with the outer corner of the model's right eye, and the pencil is tilted until it crosses the outer corner of the model's left eye.

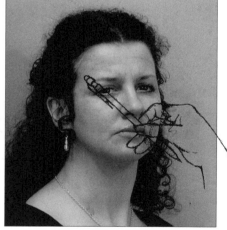

The angle between the model's right eye and base of her nose.

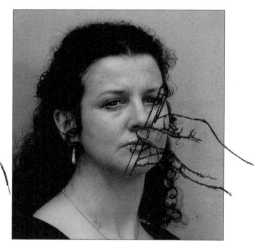

The angle between the model's left eye and base of her nose.

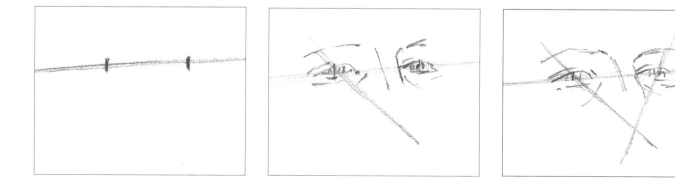

Proportional measuring

This is a method of comparing a unit of length on the model, or in a photograph, with an area on your drawing. The measurements can be the same size as your reference, enlarged, or reduced. To begin, the simplest approach is to use 'same size' measuring.

To do this, hold out the pencil at arm's length either vertically or horizontally (depending on what you are assessing). It is important that the distance at which you hold the pencil is consistent, or the measurement will be distorted.

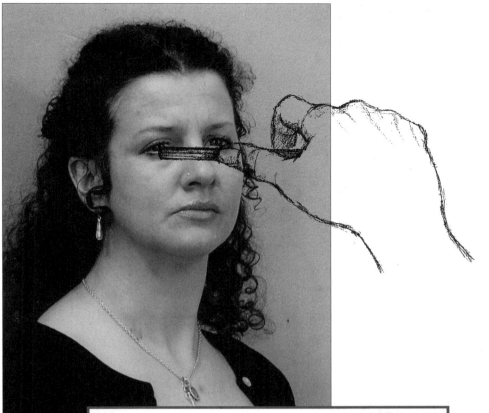

Method

1 Close one eye. Align the end of the pencil with what you want to measure, then slide your thumbnail along the pencil to determine the unit of measurement. In the example to the right, the end of the pencil is aligned with the model's right pupil and the thumbnail with the left pupil.

2 Compare this unit of length with another area of the same distance. For instance, to find out how far the ear is from the nose, measure that distance and, keeping your thumb in the same place, find an equal width or depth on your drawing – perhaps the distance from pupil to pupil, or pupil to mouth.

3 Transfer this information to your drawing; use the pencil to measure the same distance on your drawing (e.g. pupil to mouth on your drawing will equal nose to ear) and mark that on the paper.

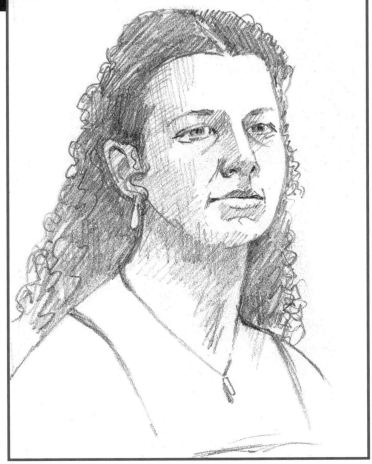

Sam

Drawing a portrait is not a mysterious process but a combination of carefully observed shapes and accurate measurements. In this exercise I show you six simple stages to create a freehand drawing, in pencil, from a photocopy.

Materials

Medium surface cartridge paper
Drawing board
Masking tape
Reference photograph or photocopy
2B and 4B pencils
Kneadable eraser

A photocopy of the source photograph for this drawing.

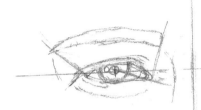

Tip

If the pose is a three-quarter view, one side of the face will be noticeably narrower than the other half. Remember this when placing the axes.

 Secure the cartridge paper to a drawing board with masking tape and elevate the top of the board to form a sloping work surface. Stick the reference photograph or photocopy to the edge of the board, squared up to the paper.

Axes Use a 2B pencil to draw in the eyeline, which passes through the centre of each pupil, above the halfway point on the paper; then draw in the vertical axis roughly at right angles to the eyeline. Although it appears to be a straight-on view, the left half of the face is actually slightly wider than the right-hand side.

Eyes Mark each pupil – this dimension will determine the size of the finished portrait. Lightly draw in the irises and the lids, studying their shape as they may not be symmetrical. Carefully observe the distance between the eyes too. Sketch the angle from the pupil to the tear duct which will help you draw the shape of the bottom lid, which cuts across the base of the iris. The lower lids are flattish compared to the more curved upper lids. Lightly mark the highlights in the eyes.

Eyebrows To plot the length of the eyebrows, lightly sketch the angle from the corner of each eye and tear duct to the brow. Note the distance from the upper lid to the brow, and their curve, then draw the eyebrows.

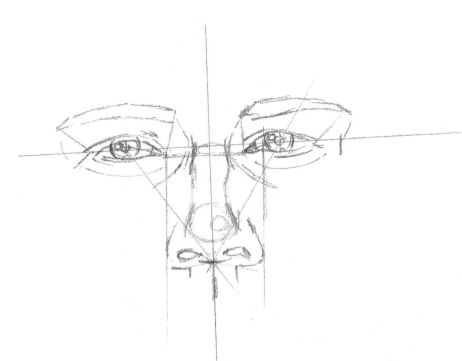

2 Nose To work out the length of the nose, measure the angle from the left pupil to the base of the nose and lightly draw in this diagonal; then repeat for the other side. The lines cross at the base of the nose. To gauge the width of the nose, hold the pencil vertically at the side of the nose and see where it intersects the eye, then repeat for the other side. Now draw the nose, outlining the shape of the end of the nose and any highlights.

3 Mouth To position the centre of the mouth, use the triangular measuring system from the pupils (as for the nose) or measure the distance from the base of the nose to the middle of the lips. To plot the width of the mouth, draw vertical lines, as before, from the corners of the mouth up to the eyes. There is really no hard outline to the lips – in fact the bottom lip is very light. The line separating the top and bottom lip is slightly wavy and needs to be drawn sensitively. To double check the width of the mouth, measure the angle to the corner of the eye, and adjust where necessary. The corners of the mouth are darker and rounded and should be turned up slightly to give a hint of a smile.

Chin Measure the distance from the bottom lip to the base of the chin and compare it with another measurement, such as the distance from the left tear duct to the centre of the right pupil. Convert this proportion to the drawing. Now sketch in the chin and jaw line.

4 Head, hair and ears To complete the outline drawing, sketch in the hairline, the neck and the shirt, taking note of the negative spaces (for instance the area between the corner of the mouth and the side of the face, the corner of the eye and the side of the head). The point of the shirt collar lines up midway through the chin. The ears align just under the eyelids and halfway through the upper lip; while the distance from eyebrow to hairline is a little less than from pupil to pupil. At this point, turn both the drawing and reference upside down to check everything looks right. Analysing the drawing like this helps you judge the shapes and proportions afresh; (see page 45 for information on upside-down drawing). Here the left-hand side of the face looked too wide so I cropped a few millimetres off and redrew the ear.

5 Shading Now start to add shading to create form and substance, breathing life into the portrait. Erase any unnecessary structural lines. To build the tone use a series of hatching and cross hatching lines and gradually darken areas in and around the eyes, the mouth and the hair with the 4B pencil. Continually reassess the likeness as you work and make adjustments and improvements where necessary.

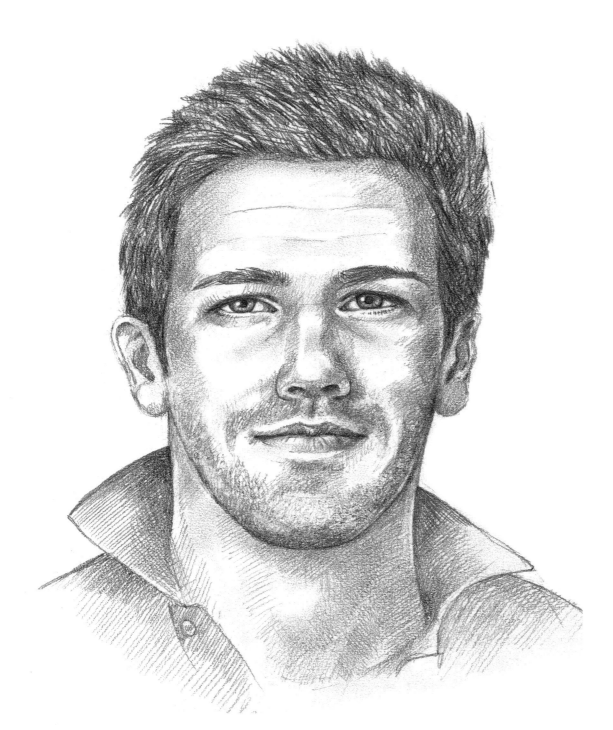

The final drawing

To complete the drawing, I increased the tonal contrast to make Sam come alive. I used a 4B pencil making vigorous marks to simulate his spiky hair. I let the hatching marks add character and variety to the drawing; elsewhere, on the cheeks and forehead I smudged in the graphite with my finger to create soft effects, then used a small piece of the kneadable eraser shaped to a point to lift out highlights and 'draw' fine lines.

With a sharp pencil I darkened the pupils, the rim of the irises and the line of the upper lids. Although Sam's shirt was black, I hatched in a mid grey, darkening it around the neck. With the tip of the pencil I dotted in stubble on the upper lip and chin and 'drew' a thin highlight with the kneadable eraser on the right jaw. Judging when the portrait is finished comes with experience but if you are happy with both the likeness and the quality of the drawing, then it is time to stop before you overwork it.

Character and expression

An amazing array of facial expressions are created by the many muscles pulling and pushing the facial tissue around. Subtly changing the shape of the eyes and mouth in particular can make striking differences to an expression– sad, happy, frightened, quizzical, or shocked.

 The following pages show examples of just a few of the many expressions of which the face is capable.

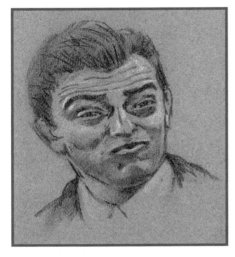

Scepticism

Note how the eyebrows are compressing the forehead, the cheeks are slightly enlarged and the chin pushes up.

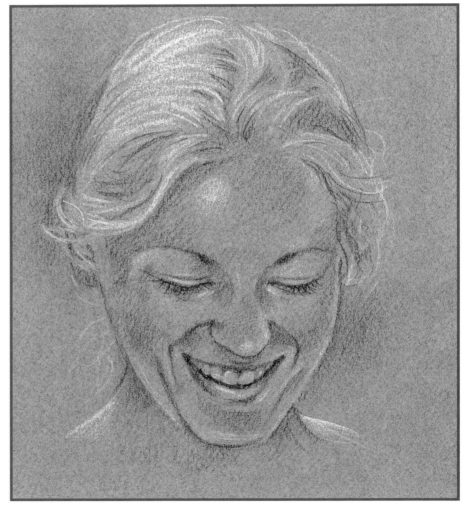

Delight

The inclined pose creates foreshortened features: the eyes, looking down, may look closed. To avoid this, you can make sure the iris is apparent.

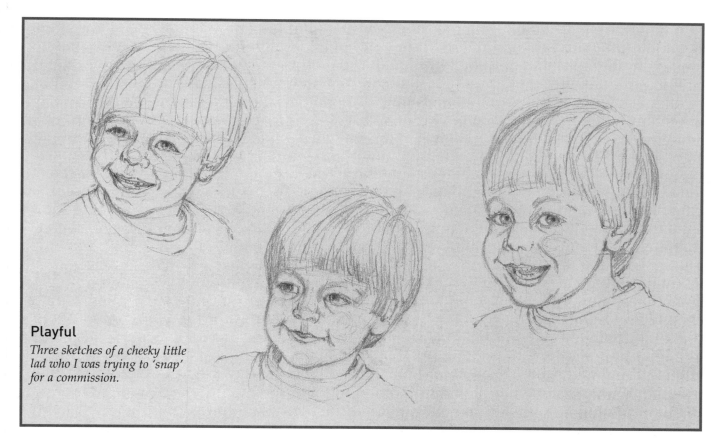

Playful

Three sketches of a cheeky little lad who I was trying to 'snap' for a commission.

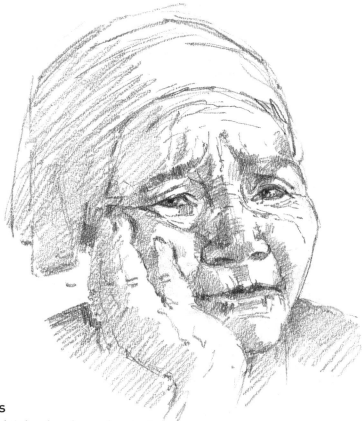

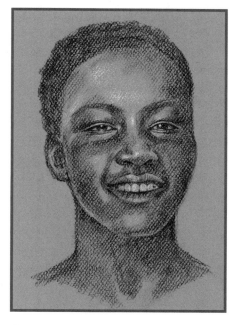

Contentment

A gentle smile, revealing the teeth without causing the eyes to close.

Sadness

The old lady's hand pushes up her cheek, magnifying the already creased skin.

Amusement

This man's broad toothy grin pushes up the cheeks, compacting the eyes. Strong sunlight casts interesting patterns across his face.

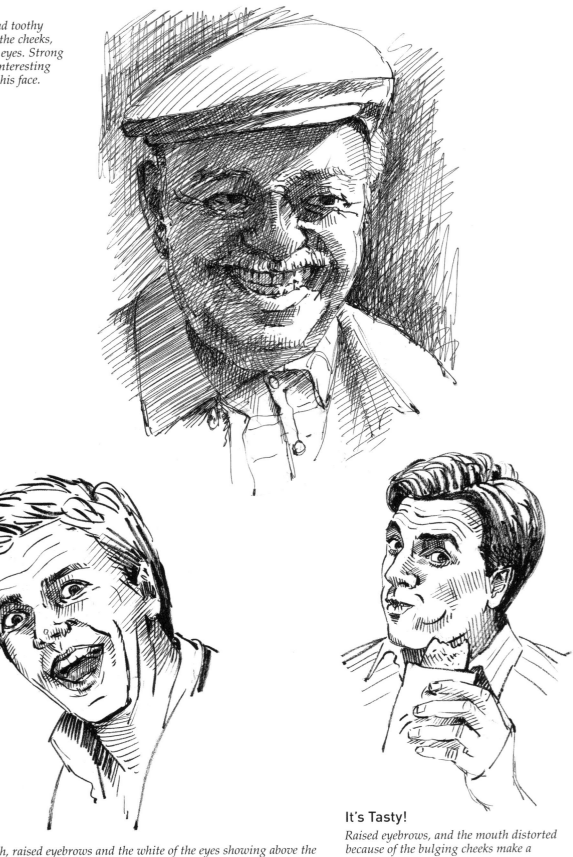

Surprise

The open mouth, raised eyebrows and the white of the eyes showing above the irises, all help to create this look of astonishment.

It's Tasty!

Raised eyebrows, and the mouth distorted because of the bulging cheeks make a comical expression.

54

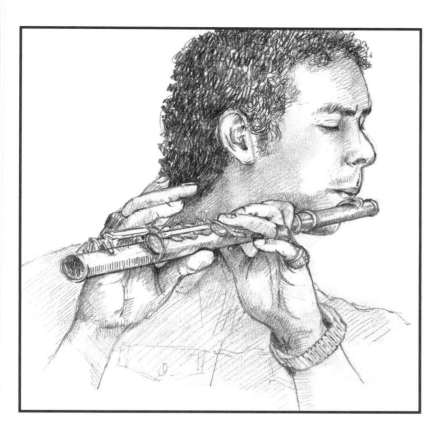

Concentration
The eyes are closed to exclude everything but the music.

Tip

Look through a newspaper and sketch as many different facial expressions as you can. They may not make what we would think of as an ideal portrait, but they provide an excellent exercise in observation.

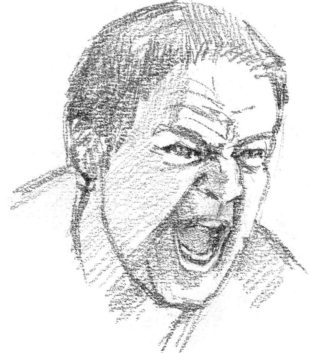

Outrage
The brows are deeply furrowed and the mouth wide open, pushing up the cheeks to compress the eyes.

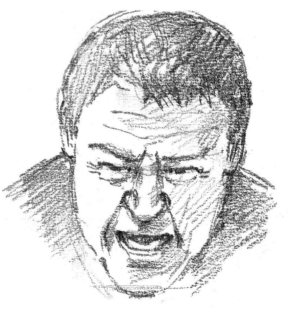

Anger
Similar to the expression to the left, the eyebrows here are lowered. The chin is thrust forwards into a nasty, jeering expression.

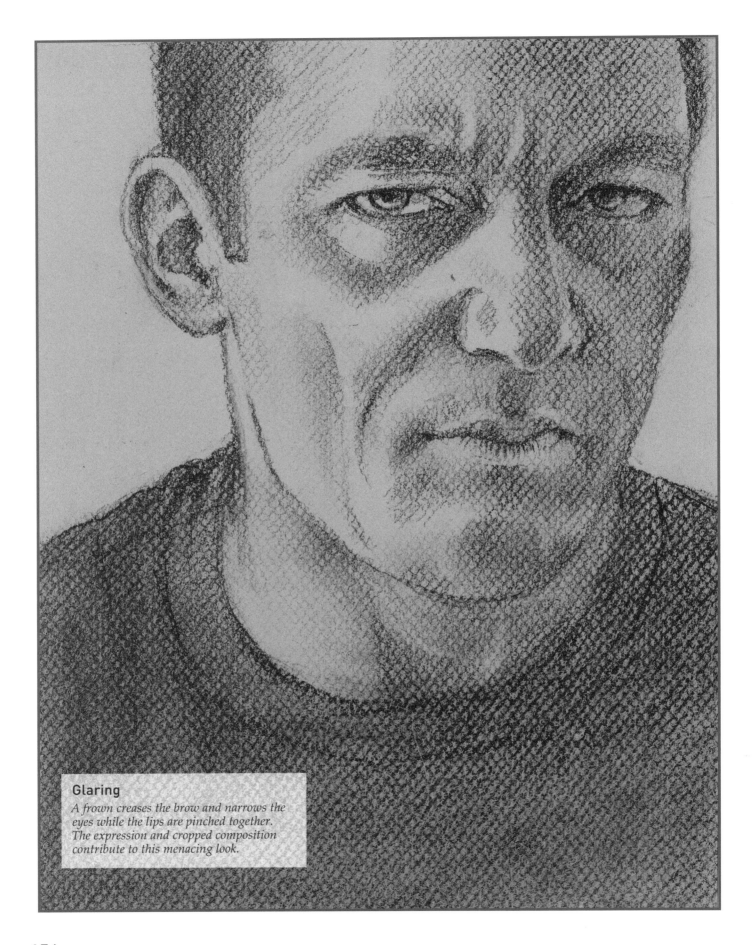

Glaring

A frown creases the brow and narrows the eyes while the lips are pinched together. The expression and cropped composition contribute to this menacing look.

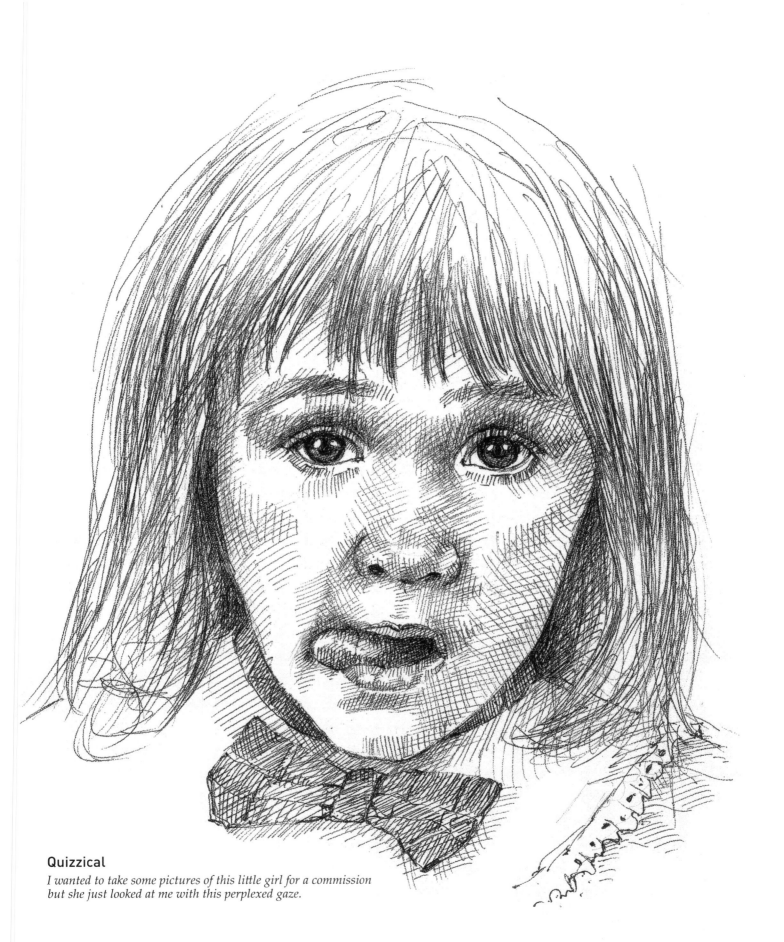

Quizzical

I wanted to take some pictures of this little girl for a commission but she just looked at me with this perplexed gaze.

Moving on

SKETCHING

'The sketch is the product of enthusiasm and inspiration, while the picture is the product of labour, patience, lengthy study and consummate experience in art.'
D. Diderot, 1767

'[A sketch is] the intermediate somewhat between a thought and a thing.'
Samuel Taylor Coleridge

If you want to improve your drawing, then sketching should be your daily exercise. Sketching will hone your observational skills, increase your speed and improve your visual memory. A sketchbook is your own personal record where you can experiment, take risks, make mistakes and not worry too much about the results. Like a photograph album it can be a document of people, places and events in your life that interest you.

Anything and everything can be included – whatever appeals to you. It is an aide-memoir and invaluable reference that enables you to try out new ideas and mess about with materials and subject matter before committing to your masterpiece. Most importantly of all, it is great fun!

Cora in a Shady Corner

The Readers

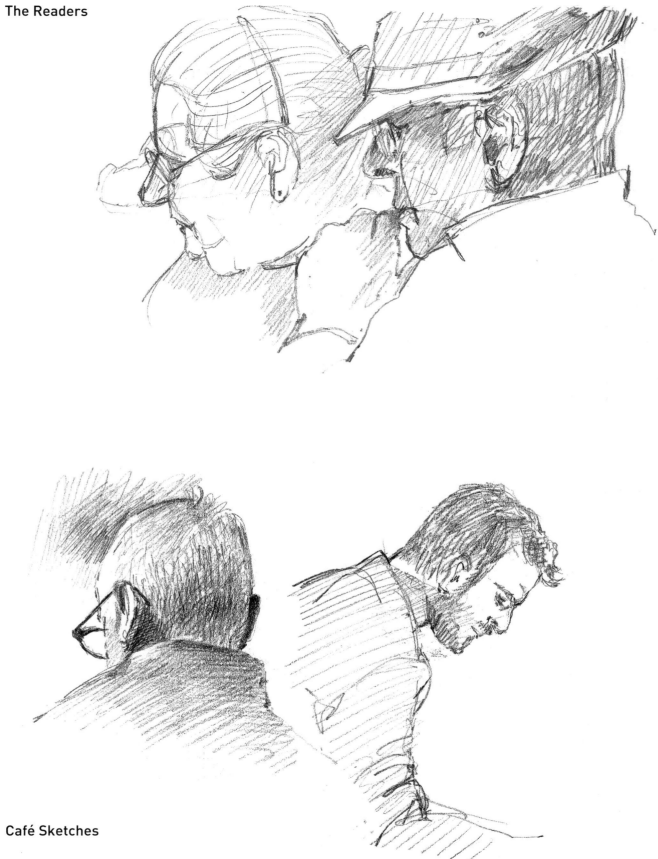

Café Sketches

USING PHOTOGRAPHS

No matter how accurate your visual memory, it is very difficult to retain the image of a particular fleeting moment, facial expression or lighting effect. Working from photographs is sometimes thought to be 'cheating' but providing you are not tempted to copy slavishly it can be an extremely good source of reference. Artists who prefer to work from life, often use photographs for an accurate reference for details such as clothing, jewellery and background. Using a 'pre-prepared' image also allows you precise positioning on the working surface.

Capturing fleeting expressions

Although working from life is arguably the best way to observe and record the character of a person, there are many times when photographs really excel; the camera can capture a precise moment in time, a fleeting look, smile, laugh or a special event which cannot possibly be otherwise recorded. I love this liberating aspect of photography, of the frozen expression. Some examples of portraits from such photographs are shown here.

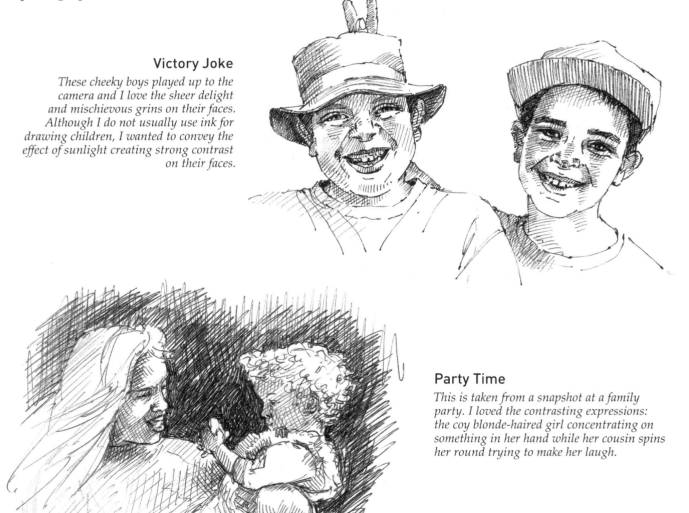

Victory Joke

These cheeky boys played up to the camera and I love the sheer delight and mischievous grins on their faces. Although I do not usually use ink for drawing children, I wanted to convey the effect of sunlight creating strong contrast on their faces.

Party Time

This is taken from a snapshot at a family party. I loved the contrasting expressions: the coy blonde-haired girl concentrating on something in her hand while her cousin spins her round trying to make her laugh.

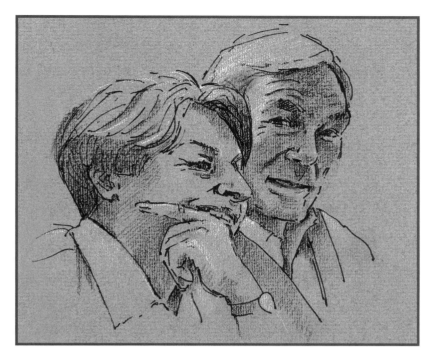

Ann and Stewart

I like to take natural photographs that catch people unawares. Here, Ann is engrossed in a conversation across the room but Stewart has glimpsed my camera and is casting a wry smile.

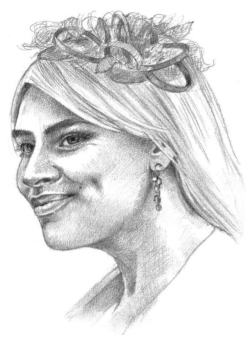

At the Wedding

The camera lens can capture natural, unposed expressions, which can be a useful source of reference.

The Parade

Near our home in Brittany we are graced with many celebrations of local traditions. I took lots of photographs of this procession of farm workers heading off to harvest and liked the friendly relationship between the two men as they marched along in the parade.

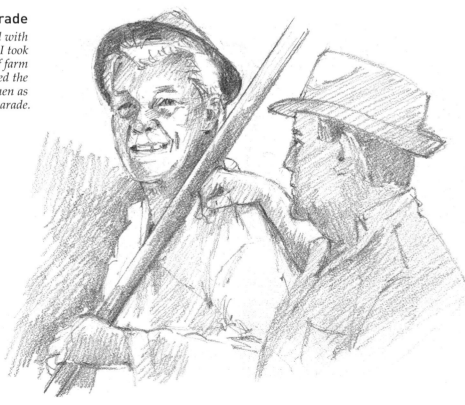

Using a grid to resize a photograph

This is a simple and straightforward way to enlarge (or reduce) an image using a prepared grid. It is a foolproof method which will help you position the head and features accurately while maintaining the looseness of freehand drawing. You could even use a grid to enlarge an image to the size of a house to paint a huge mural! It is essential, however to ensure that the enlarged image is in proportion to the photograph.

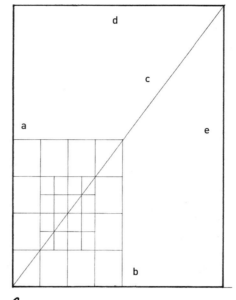

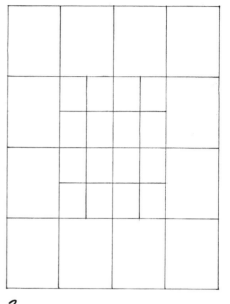

1 Tape a piece of tracing paper on top of the photograph and draw a rectangle over the selected area. Divide the width in half, then half again and do the same with the depth, creating a grid of sixteen rectangles. Divide the area over the features into more rectangles for greater accuracy (in this case, in the central area as shown).

2 Draw two lines on your working surface at right angles to one another (a,b). Place the tracing paper grid in the left-hand corner, aligning it with the drawn right angle. Draw a diagonal (c) on the tracing grid from the lower left to the upper right corners, extending it across the working surface. At any point on that diagonal, draw lines (d,e) perpendicular to lines a and b to determine the size of your working surface, which will be in proportion to the photograph.

3 Divide this larger area into a grid as you did on the tracing paper, then subdivide the area around the features into a further sixteen.

4 Place the tracing grid back over the photograph as in step 1. Note where the grid lines cross the image and, starting at the top, plot the portrait on to the larger grid.

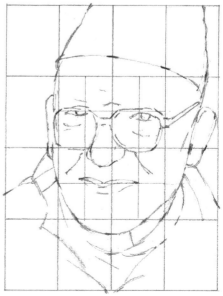

5 When you have finished transferring the image, erase
the grid lines and continue with the drawing.

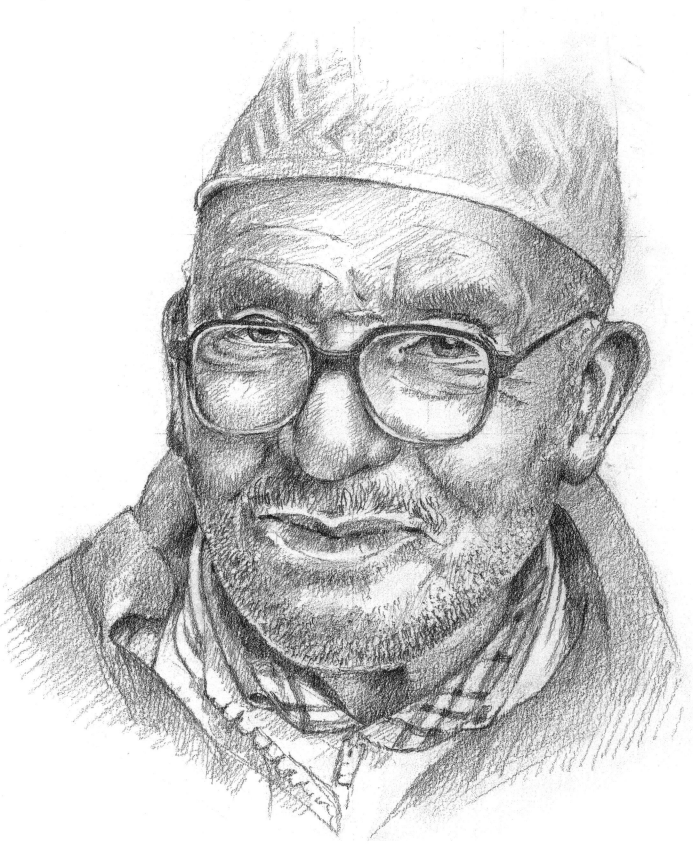

Rosie

I did lots of sketches of Rosie, and took some photographs, one of which I have used to make an enlarged photocopy. This is a relatively quick and simple way to produce an accurate representation. Even though you are tracing, each stage should present a fresh opportunity to observe and explore the subject, rather than it being a mere mechanical process. Keep referring to the original photograph which will have clearer detail than the photocopy.

MATERIALS

Tracing paper
Masking tape
2B pencil
Grey tinted pastel paper
Drawing board
Transfer paper
Ballpoint pen
Pastel pencils: black and white
Kneadable eraser
Small stump or torchon

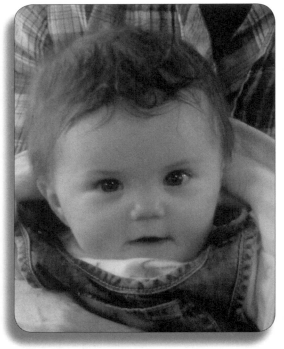

The source photograph for this drawing.

1 Tracing the image Tape the tracing paper to the photocopy at the top. Now make an outline drawing of the image in pencil, leaving out the shadows. Refer to the original photograph for any details which may have been lost in the photocopying process. Mark the position of any highlights.

2 Secure your pastel paper, smooth side up, to the board with masking tape. Elevate the top of the board to form a sloping work surface. Have your reference photograph nearby, squared up to the paper.

Transferring the image Tape the tracing to the top of the pastel paper. Slip the transfer paper underneath (dark side down) and using a ballpoint pen, draw over the pencil lines. Lift the tracing to check the image is being transferred successfully, and if necessary apply more pressure, but be careful not to damage the surface of the paper. Refer to the original and adjust the image to achieve a better likeness.

Tip

Work very carefully. You may think that tracing a photograph is a foolproof format for producing an accurate portrait; however the slightest mark, highlight or shadow in the wrong place will alter the likeness.

3 Highlights Start by using the white pastel pencil to draw in the sharpest highlights – in the eyes, on the nose and cheeks; it is essential to do this now as white pencil is not effective over black pastel.

Developing Switch to the black pastel pencil to redraw the outline. Use directional marks to mimic the growth of the hair and draw in the eyebrows with delicate strokes; a key word when drawing a child's portrait.

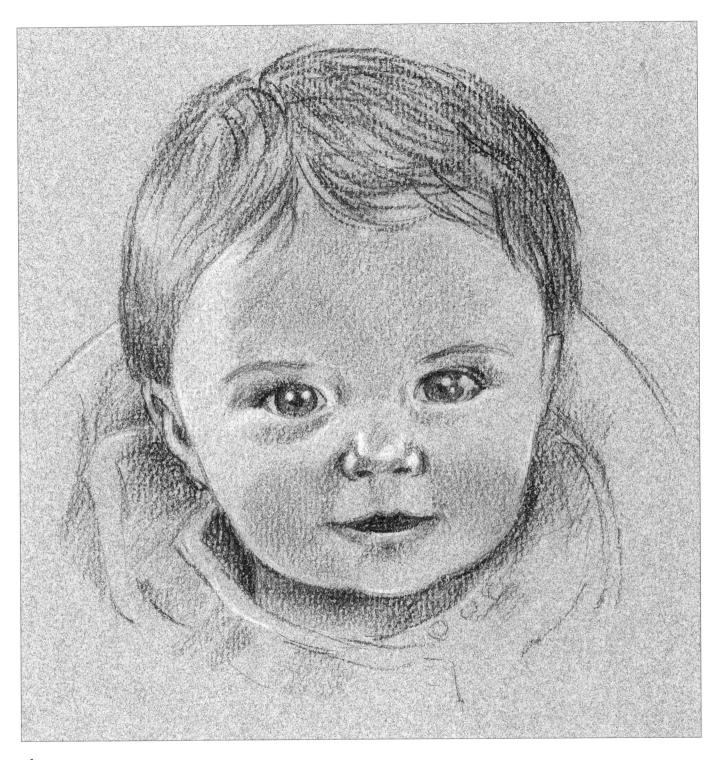

4 Increasing tonal contrast Shade in the light areas with white pastel pencil, and then the dark areas with black pastel pencil, allowing the grey paper to denote the midtones. Take out highlights with the kneadable eraser, and if there are areas that are too dark, lift them out with a dabbing action.

Blending Use the torchon to blend small dark areas such as the eyes, the mouth, the hair and those on the clothing.

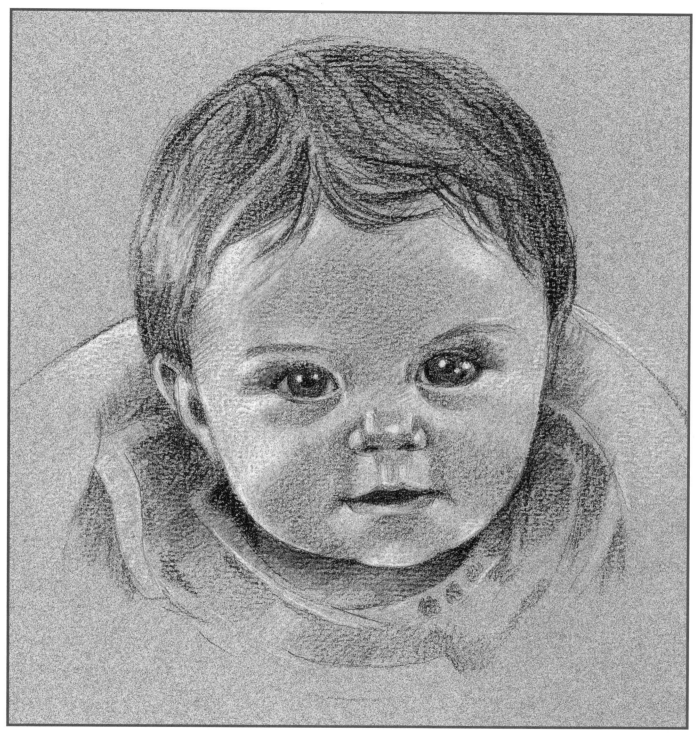

The finished drawing

To complete the portrait, add sufficient shading detail to the clothing to suggest the collar and neckline without it becoming over-accentuated. Increase some of the highlights to improve the form of the head and lastly, reapply the white highlights in the eyes. To help prevent smudging, spray the picture lightly with fixative, then cover with a sheet of paper for protection once the fixative dries.

Tip

Walk away when you think you are nearly finished and see if you really need to add anything more.

Drawing from life

WORKING WITH A MODEL

If you are working with a model, here are some considerations you may find helpful.

- Discuss suitable clothing for the model to wear beforehand; e.g. a shirt or blouse, preferably not too dark or highly patterned.

- Choose a suitable chair, which will dictate the pose. An armchair, for example, will give a more relaxed pose than an upright chair which is better for more formal poses.

- Decide on an appropriate plain or draped background, which can be light or dark to contrast with the model's skin tone and clothing.

- Consider the lighting. It should be from one source, slightly diffused and slightly above the model's head height. Artificial lighting is more controllable than daylight.

- Give the model a timescale for the sitting(s): e.g. a two hour session with five minute breaks every twenty or thirty minutes.

- Position the model so you have a three-quarter view and you are either looking slightly up at him or her, or are at the same height. You should be about 2m (6ft) from them.

- Ask the model to look at a point in the room slightly above your eyeline.

- Chatting to the model will not only allow you to gain more of an insight into their character, but it will prevent their facial muscles sagging.

- Take photographs so you can work on the portrait between sittings; this is particularly useful for working on details such as the clothing, hairstyle, jewellery or background details.

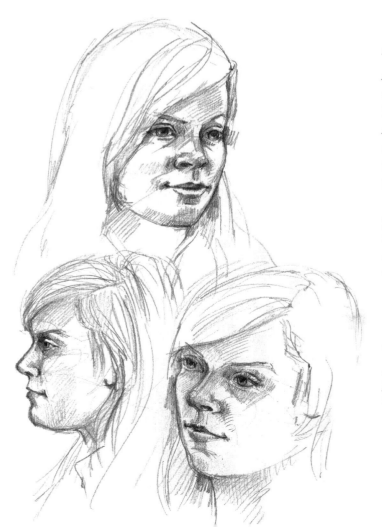

Avoiding the set expression

A sitter can, after a while, lapse into a dazed or set expression (or even fall asleep), which can result in a dull or lifeless appearance to the final portrait. A good way to avoid this is to talk to them while drawing – if you can concentrate on both! Also, ask them to look at the fixed point only when you want to paint their eyes.

Having the television on for them to look at over your shoulder, or some music playing (providing it is not soporific!) will help to keep them alert; or you could set up a mirror behind you so they could see the drawing or painting in progress.

Three Views of Lisa

Before starting a longer study, do several 'warm up' sketches from different points of view to familiarise yourself with all aspects of the model's head.

PROPORTIONS OF THE FIGURE

If you are considering a half- or full-length portrait, it is as important to get the proportions of the body correct as it was with facial proportions.

 The classic way of measuring the figure is to assess how many times the depth of the head fits into the height of the whole body. These proportions can act as a general guide. As with the features, getting the proportions wrong can change a toddler into a teenager or vice versa.

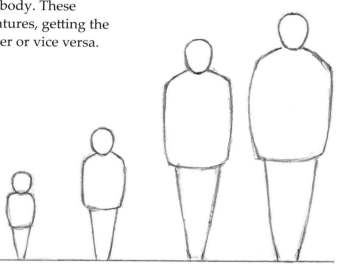

Approximate figure proportions

From left to right:

1–2 year old: Four heads tall.

5–6 year old: Five to six heads tall.

Adult female: Six to six and a half heads tall.

Adult male: Seven to seven and a half heads tall.

Sara and Rosie

The relative size of the heads is also important – an adult's heads will be larger than a child's, but the proportions detailed above remain applicable.

POSE AND BODY LANGUAGE

In portraiture we are not only concerned with the challenge of depicting the features accurately. Pose and body language can set the tone and mood of the portrait and contribute subtle and intuitive emotions. The way someone sits or stands can say a lot about their character too. Body language can describe attitude, expression and reaction to the viewer or another model: when two people are in a portrait, the way they interact can be fascinating (see *Sara and Rosie* on page 69 and *Sisterly Love* on page 73).

 When I drew Natalie I had several options, some of which are shown below. Faced with these choices it is often a good idea to do some small thumbnail sketches, much like those illustrated, to decide which is the best view.

Natalie

Here are four sketches of the same model, Natalie, in various poses. Clockwise from top left:

Full face, close-up *Natalie looks straight at the viewer, with a very direct and rather confrontational stare, which I find too severe. Although there is good detail of her head and features I do not think this pose represents her character well.*

Three-quarter view, head and shoulders *In this sketch Natalie looks unperturbed and at ease. The pose is very pleasing, showing her graceful, long neck with her head turned slightly so that she looks at the viewer without being too direct.*

Full figure *This pose is quite formal and Natalie sits well but I think it lacks interest. The background and dress dominate, which could make a good portrait study if there were more detail in the clothing. The head is nearly in profile and there is no connection with the viewer.*

Half figure *Natalie sits upright with her hands in her lap yet looks relaxed. Her mood is serene and contemplative. I like the counterbalance of dark and light areas – light head and clothing against the dark background on the left side opposed to the dark against light on the other side.*

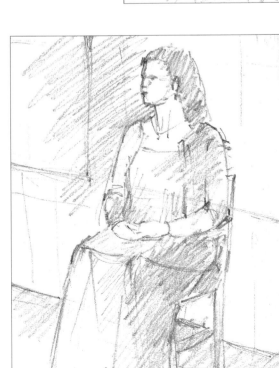

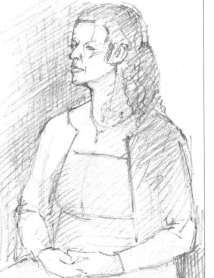

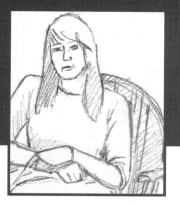

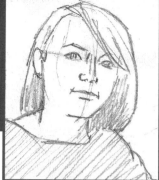

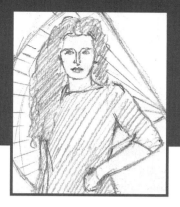

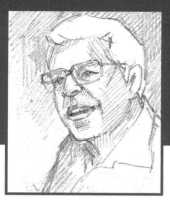

Molly

Molly lounges in a very relaxed informal pose, with her hands crossed over one another. She looks at the viewer with rather a vacant gaze. I like the calmness this portrays, contrasting with the angularity of the pose.

Alice

A head and shoulders pose, with her head slightly tilted to one side and her hair over her shoulder. She is unchallenging and looks contented with a slight smile on her lips.

Fan with Fan

This standing pose, with Fan's hand on her hip suggests confidence and power, an interpretation supported by the bold gaze directed at the viewer. Having a fan in the background mimics her name and mirrors her stance.

David

This three-quarter view, head and shoulders pose shows David caught mid-sentence, chatting to a friend off-camera. This gives an animated, active portrait and illustrates how useful the camera is for catching such informal moments.

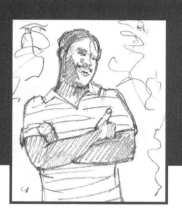

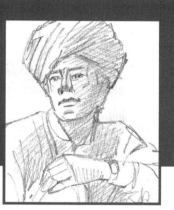

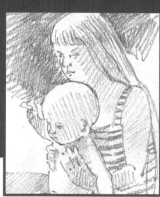

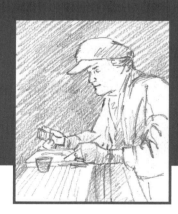

Nathaniel

Nathaniel was a jovial artist, full of humour and keen to sell his work. In this pose, with his arms crossed and head to one side he beams shyly at the camera which makes a charming study.

Man in Turban

This man squats on his haunches, his arm grasped round his knee. He looks slightly down at the viewer with a somewhat disdainful and wary expression.

Study of Two Children

This sunny study of two children depicts a mirrored pose – both are looking down, both are blonde, and the two are linked by the restraining, gentle hands of the older girl. The pose and body language of the two contribute to a sensitive and harmonious double portrait.

Daphne Painting – Portrait of an Artist

Daphne is an avid painter and in this study she was standing on the Accademia bridge in Venice, oblivious to the crowds of tourists streaming past. This natural pose shows her concentrating on the task in hand.

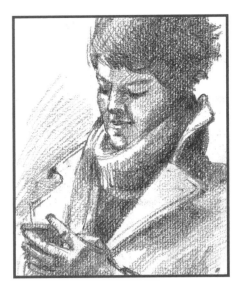

Tor Texting

What appeals in this portrait is that Tor was totally engrossed with her mobile phone when I took this photograph. She looks down with a concentrated yet smiling expression. Her head and body are cropped to exaggerate the concentration.

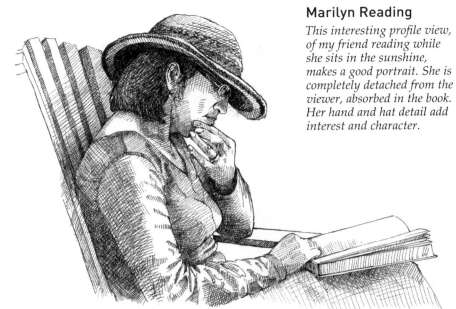

Marilyn Reading

This interesting profile view, of my friend reading while she sits in the sunshine, makes a good portrait. She is completely detached from the viewer, absorbed in the book. Her hand and hat detail add interest and character.

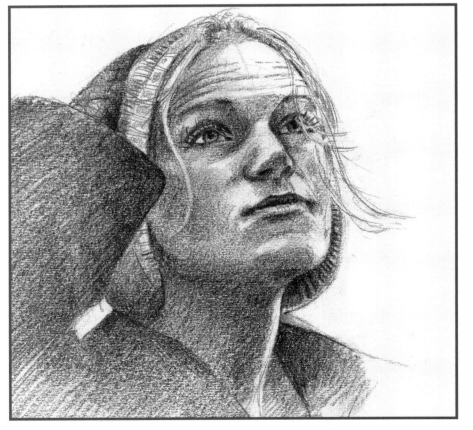

Charity Sightseeing

This is an unconventional portrait pose, as Charity gazes upwards while hanging on to her hat on a windy, wintry day. The dark flat areas of her coat contrast with her face and blonde hair.

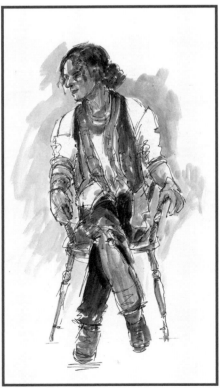

John Seated

This full figure pen and wash sketch was done quite quickly. John sits upright in the wooden chair, turning his head away to chat to someone off to the left. His body language is confident and alert.

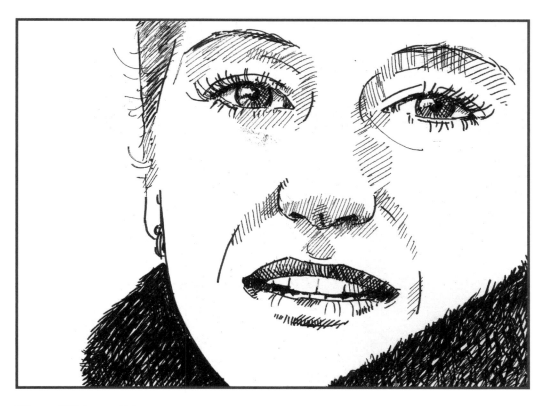

Close-up

An assured, direct pose. This young woman looks as if she is talking directly to the viewer. I chose to crop the forehead and chin to create a big close-up view emphasising the large eyes and partly open mouth, framed by the dark texture of the coat, which looks dramatic in pen and ink.

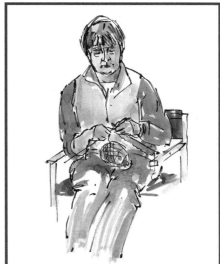

Bridget Knitting

An informal, natural pose in pen and wash. Bridget looks down as she works, appearing relaxed and quite unaware of the viewer.

Sisterly Love

Gazing passively at the viewer, these young girls look serene and calm as they hug each other in a show of sisterly affection. It makes a charming study, which I have drawn using black and white pastel pencils on tinted pastel paper.

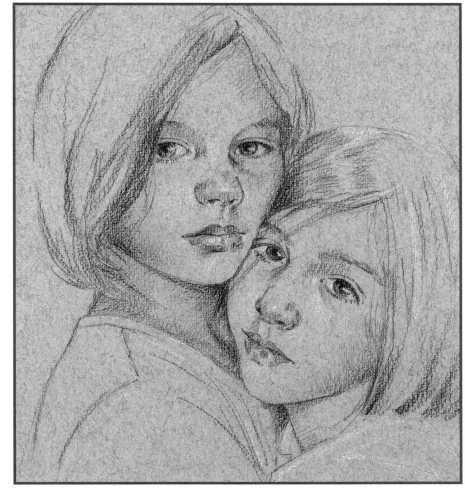

Composition

One can be inspired by and learn much from the work of artists, past and present. Visit local and national galleries to see how other portraitists have posed their models, lit them, added backgrounds and tackled the composition in their portraits. There are no set rules but some guidelines may help if you are looking for ideas for your own portraits.

To decide on the best composition, I recommend you do lots of small sketches. These analytical 'thumbnails' are an invaluable aid for all types of compositions; as well as helping to decide on the layout, you can play with tones, crop or enlarge, and they are a way of practising for the real thing.

THE GOLDEN SECTION

A classic view is based on the Golden Section proportions, a system invented during the Renaissance to organise elements in a painting in an aesthetically pleasing and balanced way. The Rembrandt-style composition on the far right (below) demonstrates this ideal composition, with the eyeline placed on the focal point of the Golden Section proportions.

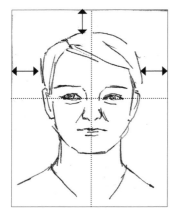 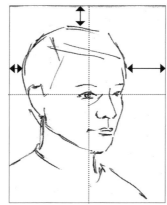 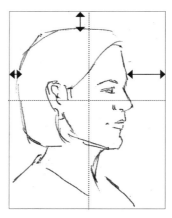 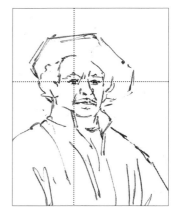

Full face view
The eyeline is above halfway, with equal spaces at the top and the sides of the head.

Three-quarter view
The eyeline is above halfway and the head placed with much more space on the right, allowing the sitter to look into the space, rather than directly out of the picture.

Profile view
The head is positioned to the left with more space on the right-hand side than there is above the head.

Rembrandt-style view
A classical pose from one of Rembrandt's many self portraits. His right eye is positioned roughly one third down and one third in from the top left of the picture.

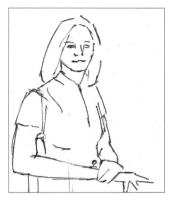

This is a conventional half body, three-quarter view pose, with the head turned towards the viewer.

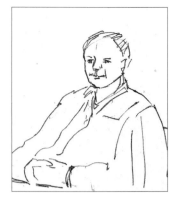

Another classical pose, showing a head and body in three-quarter view, with the hands in a relaxed position.

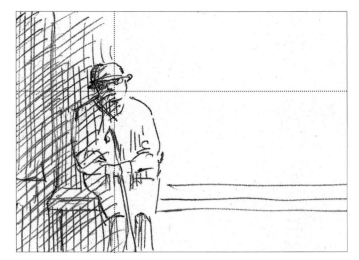

I like this offset composition and wide format. It is as much a statement about the old lady as it is a portrait of her. She sits demurely in half shadow; we don't know if she is waiting or watching but the composition tells us she alone and isolated.

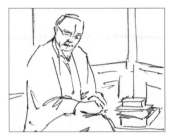

The figure sits framed against a window, with his books on the seat to one side.

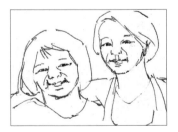

This double portrait tells a story of friendship.

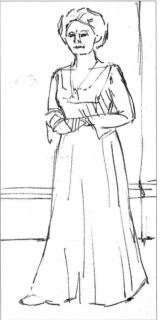

A standing pose, full figure, long narrow format. Note the horizontal lines form a counterbalance to the vertical composition.

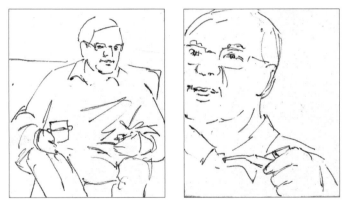

Here are two different compositions of the same model. In the left-hand pose he relaxes with his pipe and whisky. Although he looks out of the picture, the composition is balanced and there is sufficient detail to maintain the viewer's interest.

The right-hand composition breaks all the rules; our model looks out of the frame, and his head is cropped through, but the hand and pipe detail in the foreground draws the eye back into the picture. It makes a fascinating portrait and just shows that sometimes rules are there to be broken!

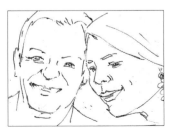

This composition, with the two heads touching, shows harmony and love.

LIGHTING

When setting up a composition it is important to consider the direction, quality and intensity of lighting on the model. Artificial light is controllable and constant. It should come from one direction and be gentle or diffused rather than too harsh.

Good lighting serves to enhance the form of the features; it should not cast heavy shadows that distort or obliterate. If you choose to use natural light, northern light is the most unchanging.

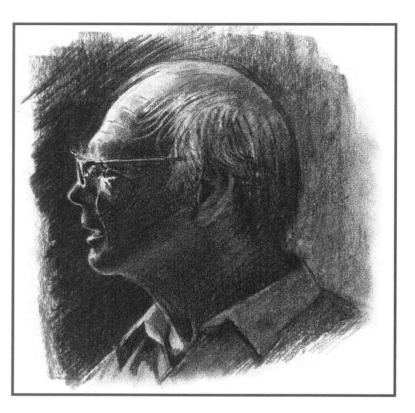

Unusual lighting

In this contre-jour profile study I love the exciting semi-silhouette effect, the features and glasses being finely outlined by the strong light source behind. Although the majority of the head is very dark by comparison, there are subtle suggestions of the form along the jaw line and in the hair detail.

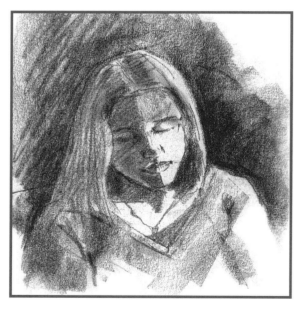

Natural Light – Young Girl Reading

Here the sun was streaming through the window; not ideal lighting for a longer session, as the shadows change quickly, but for this twenty minute sketch it adds life and vitality to the pose and makes a dramatic composition.

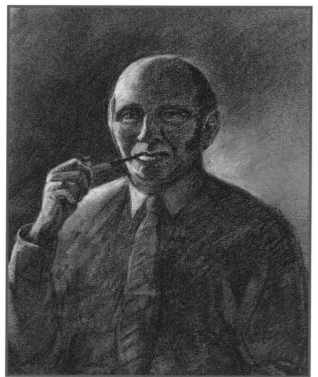

Low Light

This low-lit portrait pays homage to the great master of portrait painting, Rembrandt. His depiction of light and form, along with his ability to portray character is superb. Here, much of the head and torso is in half light, lending drama and atmosphere to this everyday pose.

Uplighting – Night Portrait

Reversing a conventional source of light can create fascinating effects. Here the emphasis is very much on the eyes. The outline of the head fades into blackness.

Ann in Brittany

Here, strong sunlight casts interesting shadows across Ann's face, which increases the form of her features. Smiling mouths are usually best avoided, but in this case it is an intrinsic part of this lady's sunny character.

Story

A deeper understanding of your subject will be gained by considering those extra attributes that he or she possesses. Adding personal touches makes for a more interesting portrait. The pose, the clothes, the accessories – a special piece of jewellery, a favourite evening gown, work or sports garments – will all add an extra dimension.

As well as furniture and props, symbolism, mirror images, active and passive movement (such as a distinctive hand gesture), or some historical reference can convey an underlying story line which will embellish the portrait and grab attention.

While I have been writing this book, I started working on a commission of a prominent figure at the Bank of England. Struggling to find the right pose, his wife mentioned that he is never without pencil and paper – that essential 'something' that will help to make the finished portrait typically 'him'.

BACKGROUND

A background can contribute a great deal to your portrait. It can describe the sitter's social status, wealth, career, achievements or hobbies; it can include family members and pets. The setting may be a garden, a work place or a library; whatever you choose will add an insight into the subject's situation and increase interest in the portrait.

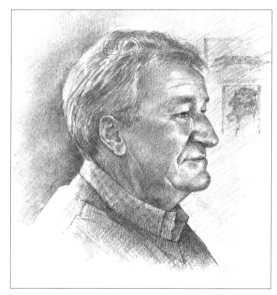

This simple background follows the maxim 'light against dark, dark against light'. The right-hand side of the head is a midtone and the background is light, whereas the back of the head is light and the background dark. The contrasting tones make the head stand out and look three-dimensional.

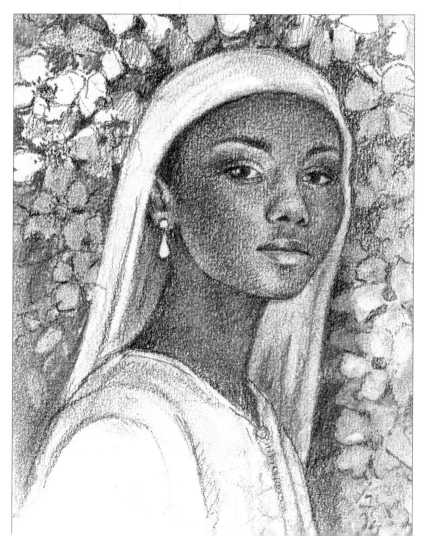

Placing the figure against a floral background brings a pretty, soft feminine feel to this portrait.

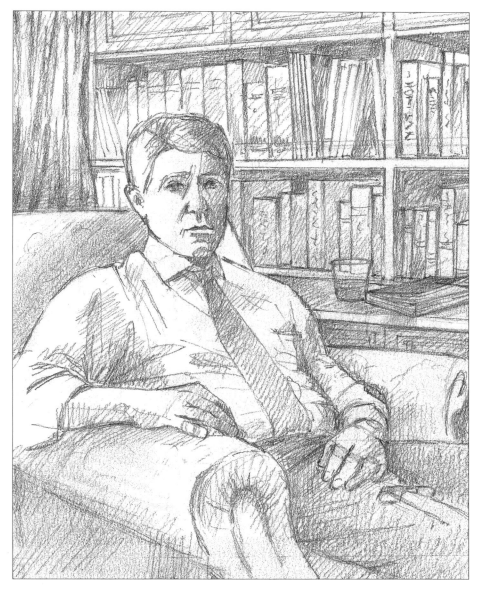

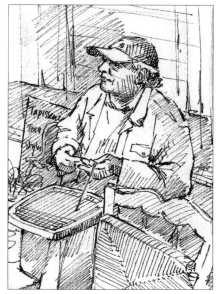

The old chair caner visits our market every week. Although he chats to all the passers-by, he never stops working so I felt his working paraphernalia should be included. As well as working from sketches, I took lots of photographs and used a combination of both to get a suitable pose. I will develop this sketch into a more detailed portrait.

This man sits comfortably in his armchair, surrounded by a background of books, which lends a scholarly feel to the portrait. A well-chosen background can contribute a lot of information about the subject, depicting profession, wealth, status, and achievements, among other aspects of the sitter.

CLOTHING AND PROPS

Neckline

How the contours of a shirt, blouse or t-shirt enclose the neck is an important, often overlooked part of the portrait. The line of clothing should wrap itself around the human form thus adding a rounded, three-dimensional feeling.

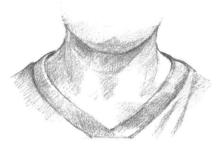

The line of a t-shirt should curve around and behind the neck.

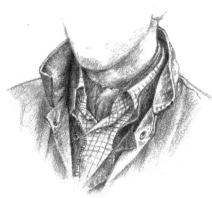

With layered clothing, each line of the layers – the scarf, shirt and jacket – curves round and behind the tubular form of the neck. Ghosting in the line of the jacket behind the neck will help you to draw each layer more accurately.

The neckline of an open-necked shirt can reveal the shape of the shoulders as well as the neck. Continuing the arc of the shirt behind the neck will help you achieve a smooth curve.

The line of a necklace is a useful aid to define the contours of the neck. The pendant marks the centre line of the décolletage.

It may help to take photographs of details such as jewellery to work on without the model present. Accessories need careful drawing, but avoid making them too prominent, as they may detract from the subject of the portrait.

Hats

Hats add character by broadening 'the story'. They are sometimes tricky to draw so try to ensure they look as if they fit the head as opposed to floating above it! It may help to lightly sketch in the shape of the skull then construct the hat around it.

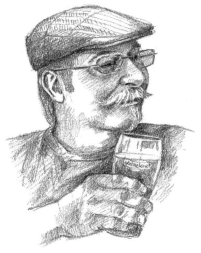

Elsie

This lady loves her hats and I think they add to and are part of her character, particularly this floral sunhat.

Man in a Trilby

A group of old farmers gathered at an agricultural show, bedecked with hats of various shapes and sizes. The challenge of drawing this hat is to get the proportions right and the interweaving curves of the brim drawn correctly.

Niel in Cap

Caps suggest more relaxed, working man's headgear; this assumption is further endorsed with the beer glass. Draw the depth of the hat carefully to make it look as if it is really sitting on the head.

Glasses

Glasses can help accentuate the planes of the face. They are useful for drawing the angle of the eyes and establishing the position of the ear. Before you start or take photographs, ask if your sitter prefers to wear them or not.

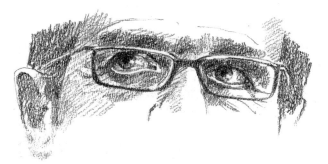

Heavier glasses can overpower the portrait and dominate the face. If necessary, underplay their weight, particularly if the frames are dark. Some lenses may catch the light, and partly obliterate the eyes; alternatively they can add sparkle to this part of the face.

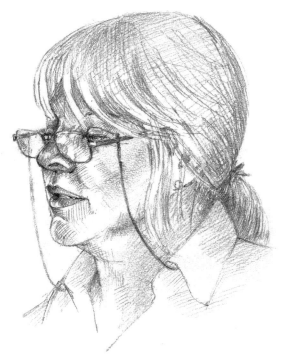

Christa

The glasses perched on the end of her nose gives my hard working pupil a studious air.

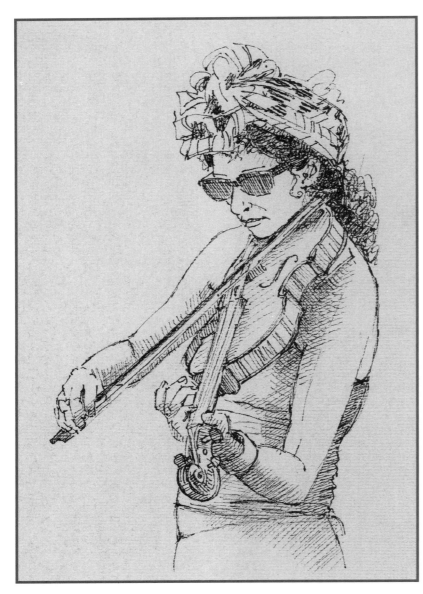

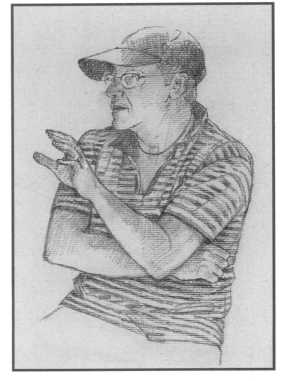

Eric

Stripes follow the contours of the body and can be very useful in helping to give shape and substance to the arms and torso without overpowering the finished drawing.

Girl with Violin

This young musician was entertaining shopping crowds. I liked her stance and style as well as her music and did several sketches and took photographs. The violin is the central axis in the portrait, and once drawn, one can construct her figure around it looking at the negative spaces.

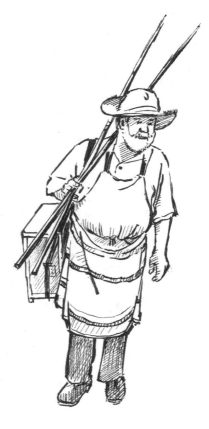

Fisherman

The working clothing, battered straw hat, braces and apron pulled over his large belly add considerable character to this full length study of a fisherman.

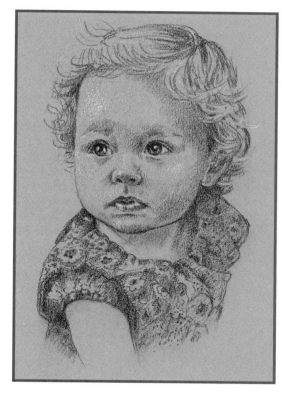

Ella

Strong patterns can dominate a portrait. The floral dress is very pretty but one needs to find a balance between enhancing the portrait and overwhelming it.

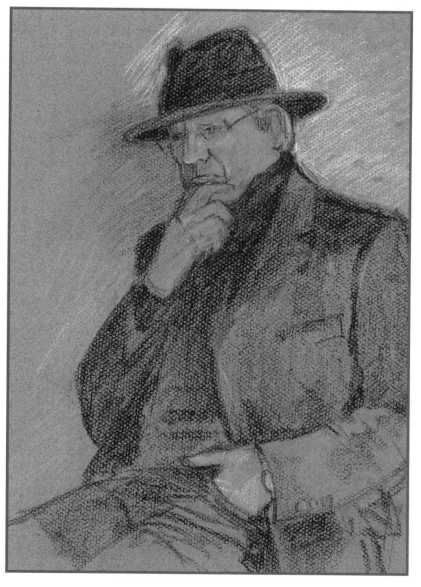

Man in a Hat

The dark hat and overcoat in conjunction with the dramatic uplighting contribute to a powerful portrait.

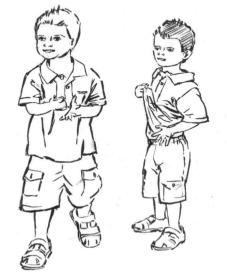

Two Little Boys

The vulnerability of these two young boys is emphasised by their baggy, oversized clothing. They look shy and apprehensive.

Maasai Warrior

This portrait is based on a photograph of a Maasai Warrior which I have enlarged using the grid method detailed on pages 62–63. There is more information on working from photographs on pages 60–63.

MATERIALS

Tracing paper
Ruler and set square
B graphite pencil
Cartridge paper
Masking tape
Drawing board
Pastel or charcoal pencil
Kneadable eraser
2mm willow charcoal

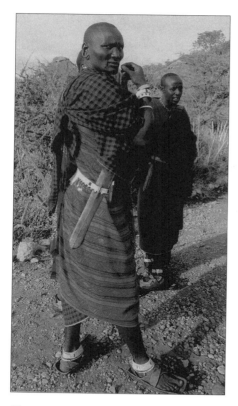

The source photograph for this drawing.

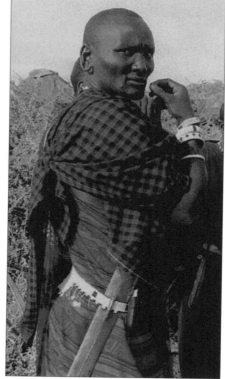

1 **Composition** Select how much of the reference photograph will make a suitable portrait. I have cropped out the other figure and much of the background to concentrate on the head and upper torso of the warrior.

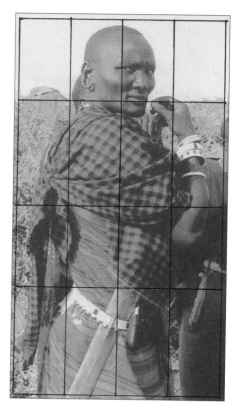

2 **Grid** Tape the tracing paper to the photograph. Select the area of the photograph to be enlarged and use the ruler and set square to draw a grid with the graphite pencil, dividing the width and the depth into four, creating sixteen rectangles.

3 Secure your cartridge paper to the board with masking tape and elevate the top of the board to form a sloping work surface. Ensure the reference photograph or photocopy is alongside and squared up to the paper.

Grid Faintly draw an enlarged grid on the cartridge paper with the graphite pencil. I have made mine 300 x 160mm (11¾ x 6¼in), twice the size of the small grid.

Initial lines Switching to the pastel or charcoal pencil, note where the grid lines cross the image on the photograph grid and duplicate the outline of the warrior on the large grid on the pastel paper.

Tip

Remember that when using charcoal or pastel you need to work on a bigger scale than with pencil or ink, as it is a broader medium.

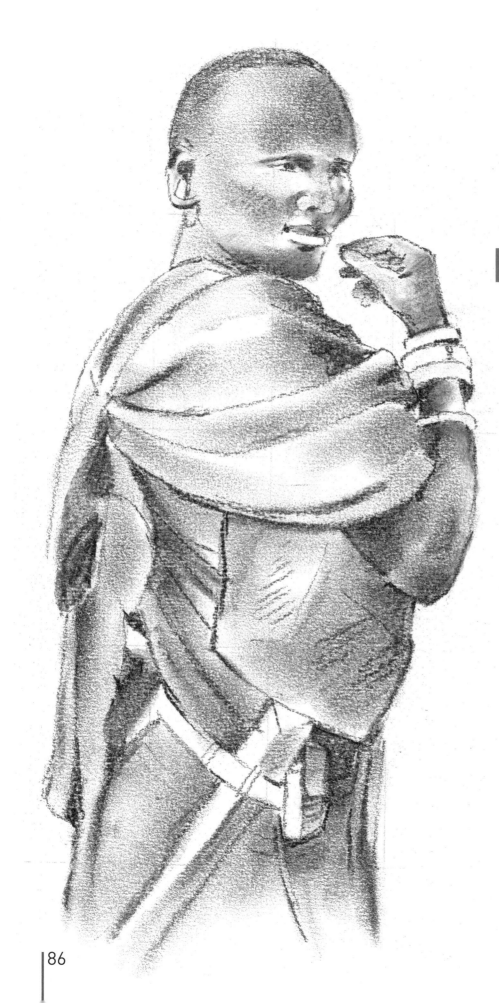

4 **Developing tone** Erase the grid lines where possible, particularly in the background. Starting at the top, use the charcoal stick to add tone in the larger areas such as the chequered and striped fabrics. Smudge the charcoal with your finger.

Detailing In more detailed areas such as the face, hand, and arm, blend in the charcoal with a cotton bud or torchon. Leave the bracelets and belt white.

Tip

To prevent accidentally smudging your work, cover it with a piece of paper taped down lightly at the edges.

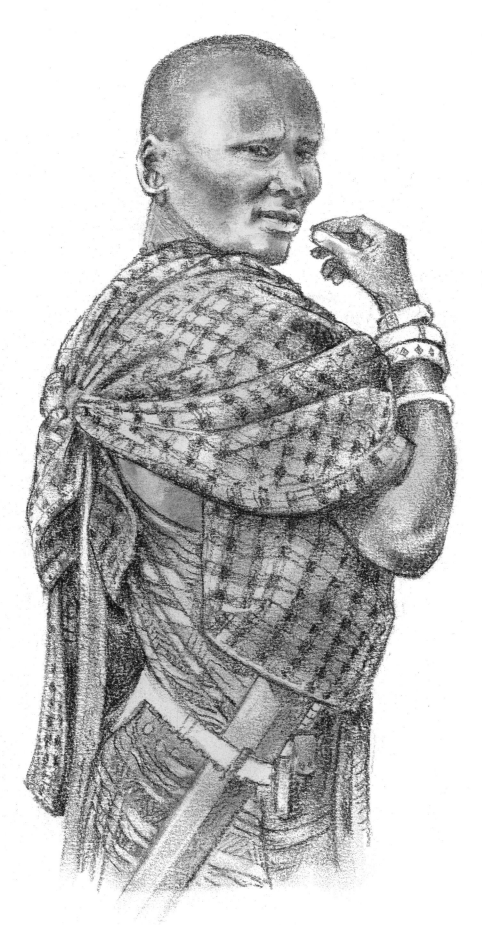

The finished drawing

To finish, lift out the highlights with a small piece of the kneadable eraser rolled between the fingers to a fine point. Using the pastel or charcoal pencil, darken the details in the eyes, nose, hairline, the hand and arm; then in the recesses of the clothing, such as the creases in the cloak and in the folds around the belt and sword.

The cloak *Draw the outline pattern of the cloak and clothing and on the bracelets, then fill in the checks and stripes, darkening their tone in the folds of the cloth and erasing where necessary to create the white areas of the design. Add details to the belt and sword to complete the portrait.*

Age

Looking at these portraits, you know instantly that one is a young child, one a teenage boy and one an old lady; you could probably guess within a few years how old they are. The differences in facial proportions of different age groups are so subtle; the tiniest change in position and size of the eyes, width of the mouth, how you apply shadow and add lines can make the difference between a five-year-old and a twenty-year-old.

Exercise

Study the variations between these portraits. Draw your own versions, and see if you can change the perceived ages by altering the proportions. For example, make the little girl look older, the youth older (or younger) and make the old lady younger – I am sure she would love it!

Youth

The facial proportions of this teenager are not yet quite those of an adult, and the pose is one with 'attitude'.

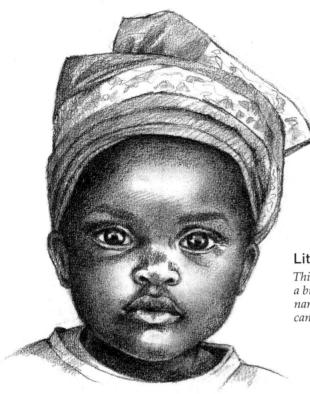

Little South African Girl

This young face is characterised with big, wide-set eyes and a button nose; her lips are full but the width of her mouth is narrow. Her head is partly covered with the headdress but we can see that the cranium is quite large.

Henrietta

With age, the eyelids thicken, the lips become thinner and there are more lines, but you do not have to put them all in! This sketch was done on grey pastel paper with grey and white pastel pencils.

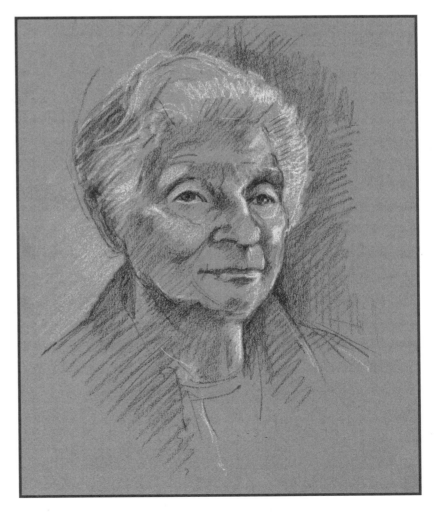

Cora

This is a freehand drawing using a pencil and a fibre-tipped pen. Cora came to one of my painting holidays in Italy; her vitality and youthful outlook belied her years. I was able to sketch her as well as taking photographs from which I have worked back home in the studio.

I did several preparatory sketches as a practice run, exploring the features, using the hatching lines to follow the contours of the face. This also helped me to decide which view to use, while practising my shading techniques for this portrait.

MATERIALS

2B pencil
Cartridge paper
0.5mm fibre-tipped pen

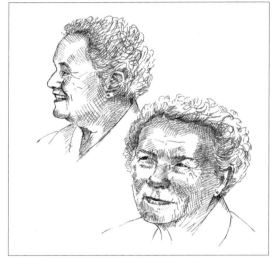

Here are my initial sketches. The profile view above shows quite a heavy brow and small eyes with a well-shaped nose, while the three-quarter view was from a higher viewpoint and did not show her eyes very well. I decided to use a third view (shown to the left), which I thought best expressed her character – looking animated and happy.

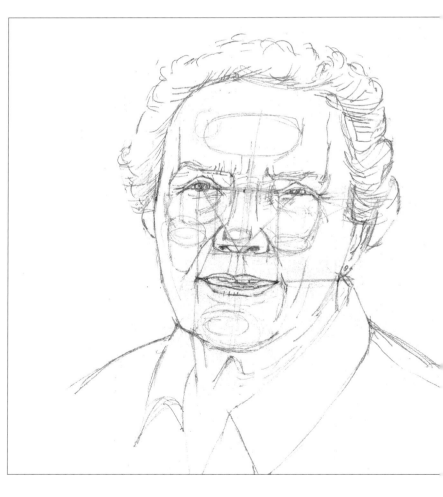

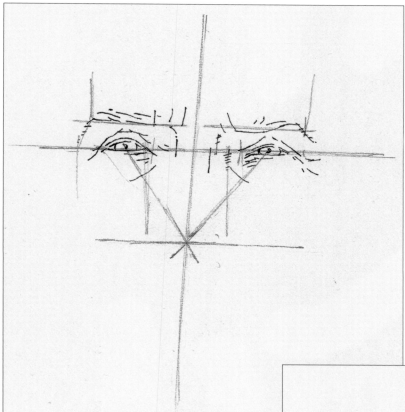

1 Axes Using the pencil, draw the angle of the eye line and the central axis on the cartridge paper, then use the triangular measuring system (see pages 42–43) to plot the length of the nose.
Eyes and eyebrows Switching to the pen, start by putting in dots to plot the position of the eyes and eyebrows then draw them in using as economical a line as possible. Use a broken or dotted line for a lighter feel, for instance for the eyebrows and creases at the corners of her eyes.

2 Nose Construct vertical lines in pencil from the nostrils to the eyes to establish the width of the nose; as it is a slightly three-quarter view, the bridge and the end of the nose, are not central. The three horizontal pencil lines ensure that the eyeline, base of the nostrils and mouth are in alignment.
Mouth Compare the distance from the base of the nose to the middle of the mouth or the base of the upper teeth. Study the shape of the lips carefully, and if necessary make the mouth a little more smiley by slightly turning up the corners. Draw in the laughter lines at the edges of the mouth, delineate the cheeks, then sketch in the chin.

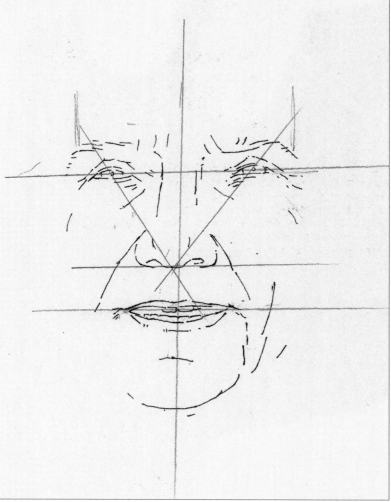

3 **Shape of the head** Now draw in the shape of the head, starting with the temple, then the cheeks, the left-hand jaw line, then the other side. Check the height of the forehead by comparing its depth with another distance, such as the width between the pupils.

Hair Draw the hairline, then the outline of hair. Coming down the right-hand side put in the ear, neck, and clothing. At this stage look at the change of plane from the front to the side of the head at the temple, round the eye socket and cheekbone and down the cheek itself.

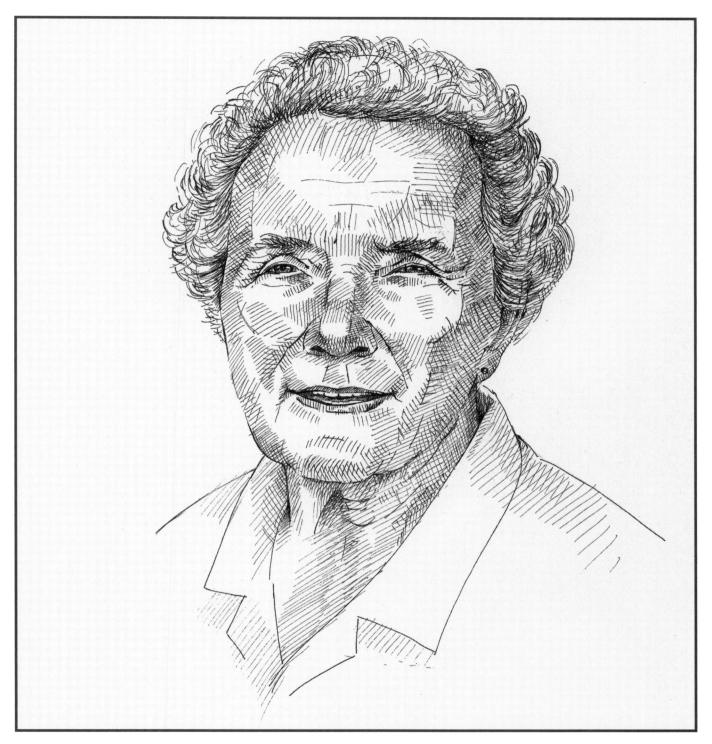

The finished drawing

The last stage of adding shading is perhaps the most daunting part using pen, so needs to be done sparingly. Add directional hatching following the planes of the head, the aim being to enhance the form, creating highlights without overdoing darker areas. Develop the lines of the eyelids where they are deeply recessed and darken the eyes, leaving small highlights. The outline of the head on the left can be broken line to create interest. Look for alternating highlights and shadows in the hair and use varied directional marks to create movement. To bring the hair and forehead into one shaded form, continue hatching on the right-hand side across both the hair and the temple. Moving on to the mouth, darken the corners and the inside of the mouth; add hatching and cross hatching marks to the neck and around the collar, darkening at the point where the neck and shirt meet.

Self portraits

If you want to work from life but do not want to go to the trouble of hiring a model or asking someone to sit, then self portraits are the answer. It is a very good way of gaining confidence at drawing from life. Alternatively, if you have more experience, you may want to push the boundaries and experiment with new ways of portraiture.

Many artists, past and present, have drawn and painted themselves. Rembrandt painted countless self portraits through times of affluence and poverty, from youth to old age, and they remain a permanent testament to his life and art.

My self portrait was sketched quickly in pen, looking into a mirror. If you want to do a self portrait as others see you, then you will need to set up two opposing mirrors to give a true representation of your 'public' face.

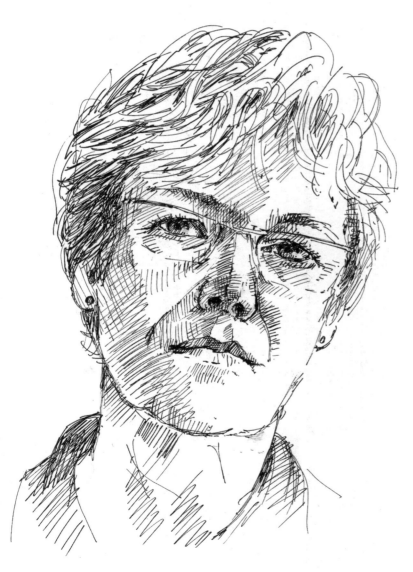

Self Portrait

I drew this self portrait quite quickly using a fibre-tipped pen, without preliminary pencil guidelines. I am concentrating hard, so look rather stern and serious.

Experimenting

There are almost as many ways of expressing a portrait as there are faces to draw. My aim in this book has been to encourage and inspire. Building on basic drawing techniques, you can experiment and develop you own style and thus become a better portrait artist. Happy drawing!

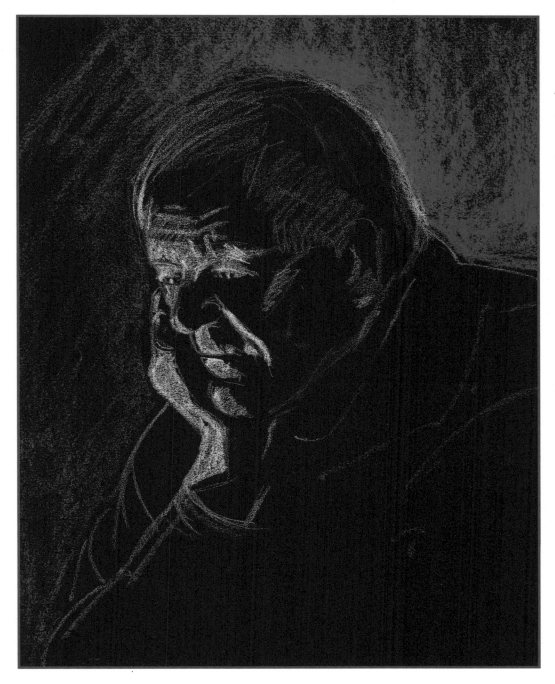

Eric – the dark side!

Only the lightest areas are drawn using white pastel on black paper. The underlighting and 'negative' technique make for a ghostly portrait giving a different approach to an 'old' and familiar subject!

Index

adult 26, 27, 32, 69
age 30, 32, 36, 37, 88
axis 42, 48, 91

baby 21, 28, 44
background 13, 20, 41, 68, 70, 71, 74, 78, 79, 86
ballpoint pen 14
beard 13, 41, 43
blending 12, 19, 66, 86
body language 70, 72
boy 28, 31, 40, 88
brow 22, 30, 48, 55, 56
brush pen 14, 15, 40

camera 18, 44, 60, 71
carpenter's pencil 10
cartridge paper 15, 16, 41, 48, 84, 90
character 52, 60, 70, 77
charcoal 11, 12, 16, 18, 19, 20, 40, 41, 86
charcoal pencil 12, 84, 87
cheek 23, 51, 52, 53, 54, 55, 65, 91, 92
cheekbones 22, 27, 30, 31, 92
child 15, 16, 28, 29, 32, 34, 39, 69, 71, 88
chin 25, 26, 49, 52, 55, 91
chinagraph pencil 10, 21
clothing 44, 50, 51, 66, 67, 68, 70, 72, 78, 80, 83, 87, 92
close-up 70, 73
composition 9, 74, 84
Conté sticks 12
contrast 41, 51, 60, 66
cross hatching 15, 20, 21, 30, 41, 50, 93

daylight see sunlight
dip pen 9, 14, 15, 40
drawing board 18, 42, 48, 64, 65

ear 26, 31, 32, 38, 39, 43, 46, 47, 50, 81, 92
easel 18, 42
electric eraser 18, 20
eraser 13, 18
ethnicity 30, 32, 36, 37
exercise 33, 35, 45, 55, 88
expression 44, 52, 55, 60, 70
eye 13, 22, 26, 28, 30, 32, 33, 39, 42, 43, 45, 46, 47, 48, 49, 50, 52, 53, 54, 55, 56, 66, 67, 73, 77, 81, 87, 91, 92
eyebrow 26, 28, 30, 32, 38, 43, 48, 50, 52, 54, 65, 91
eyelashes 13, 32, 33

eyelid 31, 32, 33, 43, 48, 50, 89, 93
eyeline 26, 27, 28, 31, 42, 43, 46, 74, 91, 93
eyes/nose triangle 42, 43, 49, 91

facial hair 13, 41, 43
Fauvism 9
features 13, 15, 22, 32, 43, 44, 52, 70
fibre-tipped pen 14, 21, 90, 94
fixative 18, 67
focal point 74
foreground 75
forehead 23, 24, 51, 52, 73, 92
foreshortening 44, 52
form 20, 50
full face 26, 28, 36, 42, 70, 74

gender 30, 36
geometrical shapes 44
girl 21, 28, 39, 42, 57, 60, 76, 82, 88, 89
graphite pencil 10, 15, 16, 20, 21, 27, 30, 51, 84
graphite stick 10, 21
grid 62, 63, 84, 85, 86

hair 13, 28, 31, 40, 41, 42, 43, 50, 51, 65, 66, 68, 72, 76, 92, 93
hairline 50, 87, 92, 93
half figure 70
hatching 15, 20, 21, 25, 30, 41, 50, 90, 93
head 25, 50, 70
head and shoulders 70, 71
highlight 12, 13, 18, 20, 21, 24, 27, 31, 33, 34, 36, 40, 49, 51, 64, 65, 67, 87, 93

iris 32, 33, 48, 52, 54

jaw 22, 28, 39, 49, 76, 92

kneadable eraser 12, 18, 20, 21, 48, 51, 64, 66, 84, 87

life drawing 37, 94
life model 36, 42, 43, 68, 74, 75, 94
lifting out 20, 66, 87
lighting 60, 68, 74, 76
light source 33, 44
lips 24, 27, 31, 36, 37, 49, 50, 56, 89, 91

Maasai 84
masking tape 18, 48, 64, 65, 84
measuring 45, 46, 47, 48
midtone 16, 78
model see life model
modelling 8, 9
mouth 21, 26, 27, 28, 32, 36, 41, 42, 46, 50, 54, 55, 66, 73, 77, 89, 91, 93

neck 23, 50
negative shape 15, 43, 50, 82
nose 22, 26, 27, 28, 30, 31, 32, 34, 35, 38, 42, 43, 46, 49, 65, 87, 89, 91
 bridge 34, 35, 91
nostrils 34, 46

old 16, 21, 32, 38, 53
outline 20, 64
overworking 13, 51

paper 15, 16, 21, 41, 45
pastel 18, 19, 20, 84, 85, 87, 95
pastel paper 16, 21, 64, 65, 66, 73, 89, 95
pastel pencil 12, 21, 64, 65, 66, 73, 84, 85, 87, 89
pen 14, 16, 20, 41, 43, 47, 72, 73, 93
pencil 10, 15, 16, 20, 21, 27, 30, 42, 43, 46, 47, 48, 49, 50, 51, 85, 90
personality 8
perspective 8, 23
photograph 9, 15, 37, 42, 45, 47, 48, 58, 60, 61, 64, 68, 80, 81, 84, 85
plane 24, 27, 44
pose 9, 68, 70, 71, 72, 73, 78
profile 8, 26, 28, 36, 39, 72, 74, 90
propelling pencil 10, 41
proportions 15, 26, 27, 28, 29, 30, 44, 47, 50, 62, 69, 88
pupil 43, 47, 48, 49, 50, 92

Rembrandt 74, 76, 94
reference 15, 48
resizing 62, 84

self portrait 9, 94
shadow 8, 24, 34, 36, 44, 65, 77, 88, 93
shading 13, 20, 21, 43, 50, 66, 67
shape 44, 48

sketch 15, 44, 53, 55, 58, 59, 64, 68, 74, 82, 89, 90
sketchbook 18, 58
skin 31, 53, 68
skull 22, 26, 34, 39, 41
smudging 12, 13, 20, 51, 67, 86
stippling 20, 51
structure 22, 38, 50
stubble 21, 51
sunlight 54, 60, 68, 72, 76, 77
surface 25, 60, 62

tear duct 26, 30, 32, 43, 46, 48
teeth 22, 28, 36, 37, 53, 91
temple 23, 25, 92
texture 16, 41
three-dimensional 20, 21, 43, 78
three-quarter 8, 26, 28, 32, 33, 39, 43, 48, 68, 70, 74, 75, 90, 91
tinted paper 13
tone 9, 20, 21, 44, 50, 51, 66, 86
torchon 12, 19, 64, 66, 86
tracing paper 18, 62, 64, 84
transfer paper 18, 64, 65

uplighting 44, 77, 83, 95
upside-down drawing 45, 50

white pastel pencil 12, 21, 65, 66, 73, 89
willow charcoal 12, 13, 84